D1090808

THEN & NOW

FREDERICKSBURG

Judge not a monument by its size but rather by its importance. Such is the stone memorial on Washington Avenue. In 1777, Thomas Jefferson, George Mason, and others met at Smith's Tavern in Fredericksburg to draft the Virginia Statute of Religious Freedom. The document inspired the First Amendment to the U.S. Constitution. This stone monument to religious freedom was erected near Maury School in 1932. In celebration of the nation's bicentennial, it was moved to its present location, where religious freedom ceremonies are held each January. (Central Rappahannock Heritage Center.)

THEN & NOW

FREDERICKSBURG

Tony Kent

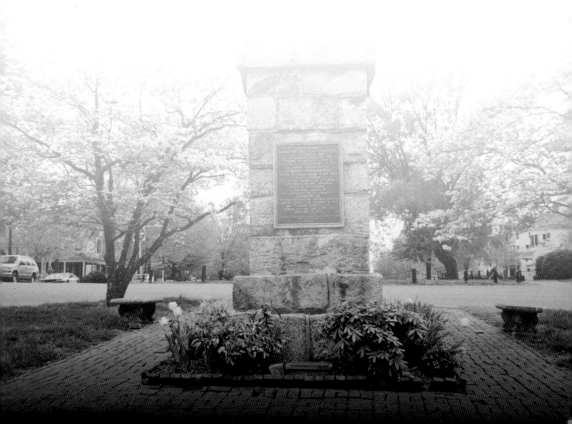

This book is dedicated to all who went before us and had the wisdom to save and perpetuate the history of Fredericksburg, and also to the contemporary generation who now has its own opportunity to continue a legacy thrust upon them and carry forward the town's proud standard.

Copyright © 2010 by Tony Kent
ISBN 978-0-7385-8661-8

Library of Congress Control Number: 2010926559

Published by Arcadia Publishing
Charleston, South Carolina

Printed in the United States of America

Then and Now is a registered trademark and is used under license from
Salamander Books Limited

For all general information, please contact Arcadia Publishing:
Telephone 843-853-2070
Fax 843-853-0044
E-mail sales@arcadiapublishing.com
For customer service and orders:
Toll-Free 1-888-313-2665

Visit us on the Internet at www.arcadiapublishing.com

ON THE FRONT COVER: The pharmacy at 901 Caroline Street was William P. Goolrick's second drugstore in Fredericksburg. The original store was directly across the street on the northwest corner. The great fire of 1807 spared that store but devoured the block on which Goolrick's now stands. Goolrick owned the land and built the present drugstore in 1808. Goolrick's Modern Pharmacy, with its classic lunch counter, is a piece of Americana and a favorite photo op stop for campaigning politicians. (Then, Valentine Museum; now, TK.)

ON THE BACK COVER: D. Letcher Stoner, a partner in Fredericksburg Hardware, was always a collector of agricultural tools, implements, and memorabilia. He envisioned a museum to house his collection. Eventually, he found a location close to home at 1202 Prince Edward Street. This was the former site of Fredericksburg College, a Presbyterian school. The Stoner Store Museum displayed everything from when life in the country was the norm. The time came when he had to close the museum and dispose of its collection. The building is now residential. (CRHC.)

CONTENTS

ACKNOWLEDGMENTS

Then & Now: *Fredericksburg* could not have been produced without the support and encouragement of many friends and former colleagues. Among those who made it possible are the leaders and volunteers of the Central Rappahannock Heritage Center (CRHC), who provided office and computer facilities as well as access to extensive records and files. Thanks especially to CRHC chairman O. Clinton Jones III and to (in alphabetical order) Diane Ballman, Judy Chaimson, Jerry Jernigan, and Susan Stone.

Also, much research data was made available by Historic Fredericksburg Foundation, Inc., (HFFI) through the generous aid of director Sean Maroney, office manager Lori R. Syner, and Megan Higgins.

I want to thank Larry Duffee, Joe Wilson, and Ben Hicks for their generous contributions. Their photographs are noted (LD), (JW), and (BH). Other photographs are courtesy of the Library of Congress (LOC), the Valentine Museum of Richmond (VAL), and the *Free Lance–Star* (FLS). All "now" images are the author's (TK).

While for me this has been an intense exploration of the history of Fredericksburg buildings, I could not have had a more knowledgeable and respected authority to guide me than Barbara Pratt Willis. My sincere thanks.

I am indeed indebted to Kathleen and Don Edwards for their exhaustive proofing and computer expertise, which greatly smoothed the way to publication.

Finally, I thank my wife and best friend, Patricia, for her editor's eye and unfailing support.

INTRODUCTION

Fredericksburg, a relatively small town situated midway between Washington, D.C., and Richmond, Virginia, the state capital, is justly known as America's most historic city.

What began as a small river settlement grew into a busy port and became a town connected to leading statesmen and key figures of the Revolutionary War and the site of epic Civil War battles.

Fredericksburg was the boyhood home of George Washington and was later where his mother lived, as did his sister Betty, wife of Fielding Lewis, who manufactured guns for the Revolution. It was for a time home to Matthew Fontaine Maury, "Pathfinder of the Seas." Here James Monroe practiced law before he became the nation's fifth president.

These and other figures of American history lived in Fredericksburg or met here to map strategy. Among the latter was Thomas Jefferson, who met with George Mason and others to draft the Virginia Statute of Religious Freedom, the inspiration for the First Amendment to the U.S. Constitution. A monument on Washington Avenue in the city commemorates the event.

Fredericksburg was home to ordinary citizens who saw their town repeatedly occupied by Federal forces in the Civil War and saw it the target of massive bombardment by Union guns. Those who evacuated returned home to find their town shattered. Partly because of that shelling, Fredericksburg today is a patchwork of architectural styles.

The city has been swept by fire and flood. However, it survived the Great Depression better than many American towns, because a huge cellophane plant on the outskirts provided employment to hundreds. Clothing manufacturing also provided employment.

The 1970s were not kind to Fredericksburg. The city could scarcely pay its bills or its employees. This was when the big nationally known chain stores departed downtown for a new shopping mall on the outskirts. That was yesterday. The storm was weathered, and Fredericksburg moved on. Downtown since has experienced rebirth.

Professionals such as Frances Benjamin Johnston and others recorded the best and the worst of what they saw in vintage photographs. Preserved on film are the gracious old mansions, the mom-and-pop corner groceries and drugstores, the pitiful pickle factories, and the workers' tenements. Such is the story of Fredericksburg, the good, the bad, and the indifferent.

Fredericksburg's population has changed little, growing from an estimated 6,000 souls in the middle of the 18th century to today's scant 22,000. But it is the nucleus of a fast-growing area. Neighboring Spotsylvania and Stafford Counties now have some 300,000 residents, many of whom commute to jobs in Washington, D.C., or to the nearby military installations: the U.S. Marine Corps at Quantico, the U.S. Army at Forts Belvoir and A. P. Hill, and the U.S. Navy at Dahlgren. Other major employers include the 100-year-old University of Mary Washington and the expansive Mary Washington Hospital Healthcare complex.

Being America's most historic city, the area attracts over one million visitors annually.

Many come with history in mind. Others come to do genealogical research at the James Renwick Jr.–designed courthouse, the regional library, or the Central Rappahannock Heritage Center. Many others opt to visit the Civil War battlefields nearby or the area's numerous museums.

The City of Fredericksburg operates with a city manager form of government with a mayor and council. It is a green-leaning community with an emphasis on parks and recreational space. Currently, a riverside park just a block from the downtown shopping district is being developed. The city boasts many hiking and biking trails and is planning more. The city obtained a conservation easement on a very large tract of land upstream along the Rappahannock River to preserve its pristine beauty for future generations.

There is much to be appreciated in this friendly, hospitable, and vibrant Virginia city. It is old, it is new, and it is ever America's most historic city.

THE EARLIEST TIMES

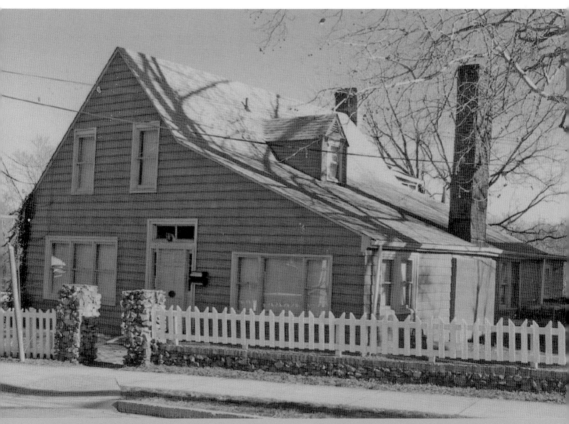

By most standards, the small cottage at 523 Sophia Street, called Thornton's Tavern and later Hunter's Store, is quite enchanting, a standout among its neighbors. It is Fredericksburg's oldest surviving building, dating from 1746. It has survived floods and a fire in the chimney and escaped severe damage in the Civil War. But more importantly, it survived the threat of demolition, which claimed so many tenements, warehouses, and other neighboring structures along Sophia Street in the 1950s. (TK.)

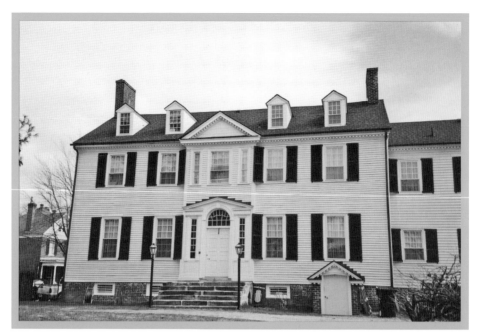

Just a few blocks from downtown is a gem of a Georgian manor listed on the National Register of Historic Places. This is Federal Hill, built around 1792–1794 by Robert Brooke, the third governor of Virginia. It was then sold to Thomas Reade Rootes, who, unlike Brooke, was an ardent Federalist. He named his home Federal Hill. Another prominent owner was Dr. Richard Lanier, the driving force to create a monument to Confederate sergeant Richard Kirkland, the "Angel of Marye's Heights." At 500 Hanover Street, Federal Hill has been beautifully restored. (Above, TK; below, HFFI.)

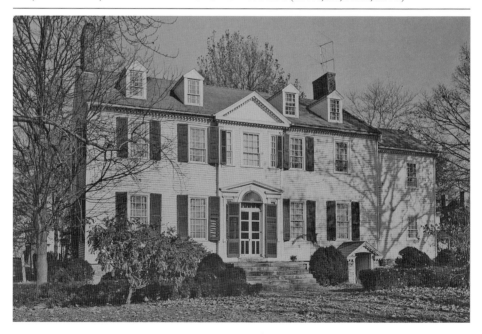

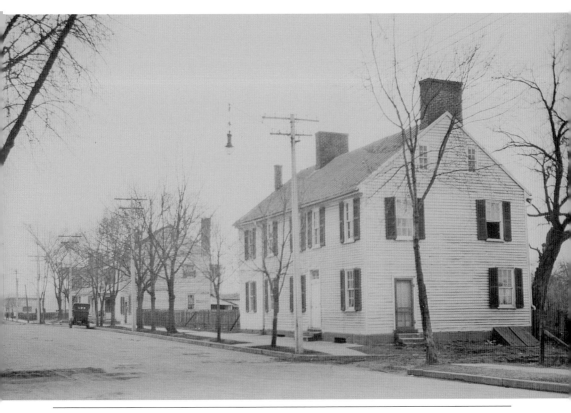

This 18th-century frame house once on the northern outskirts of town was built by Dr. Robert Wellford and later owned by his son C. C. Wellford, a prominent business merchant and leader in the Presbyterian Church. The latter also came to fame when he and 18 others here were arrested by Union forces. They were whisked off to Washington's Old Capitol Prison as hostages in retaliation for the arrest of two Union men. Six weeks later, Wellford and the others were set free. The home at 1501 Caroline Street has weathered the years to remain one of Fredericksburg's finest. (Above, HFFI; below, TK.)

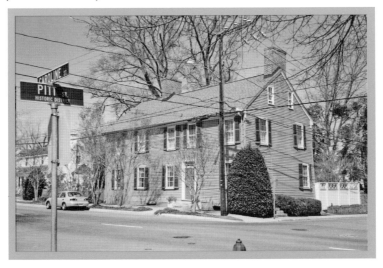

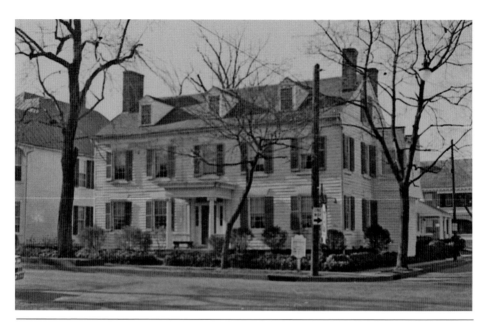

This private pre-Revolutionary residence at 1114 Charles Street was from the 1930s to 1950s, the Betty Washington Inn. It is situated across the street from the Mary Washington House and has been owned over the years by some of Fredericksburg's elite, including Col. Fielding Lewis, Charles Dick, merchant John Frazer, and physician George French. Others included Robert Chew, Robert Stanard, George Minor, William H. Fitzhugh, and Charles Binns. Outwardly, the old Betty Washington Inn has changed little. (Above, HFFI; below, TK.)

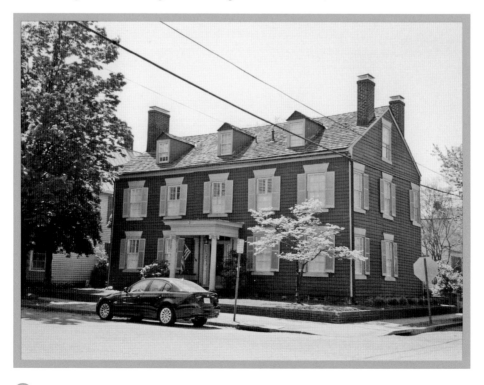

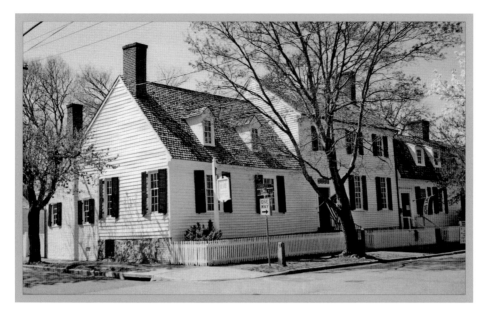

The Mary Washington House at 1200 Charles Street was almost dismantled and shipped off to Chicago in 1893 for the Columbian Exposition. Exposition promoters were shrewdly aware that the home of George Washington's mother would have fantastic appeal. Fortunately, a group of civic-minded ladies of Fredericksburg said "not so fast" and saved the 1760s cottage. It is open daily and owned and maintained by the Association for the Preservation of Virginia Antiquities. (Above, TK; below, CRHC.)

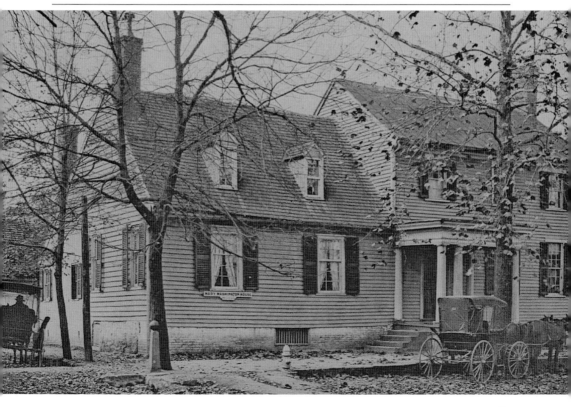

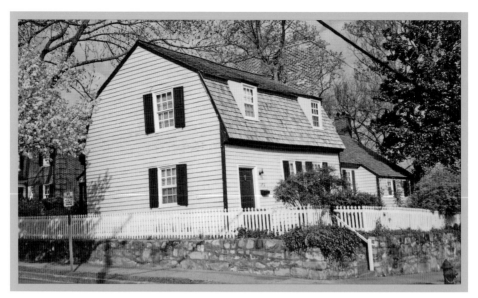

The St. James House at 1300 Charles Street was built in the 1760s by James Mercer, the lawyer who wrote the will of Mary Washington, the president's mother. It received its name in honor of a street in Dublin, Ireland, where the family home was located. Mercer was later named judge of the Virginia Court of Appeals. The home is now owned by the Association for the Preservation of Virginia Antiquities. It is open to the public twice a year, in the spring and again in the fall. (Above, TK; below, LOC.)

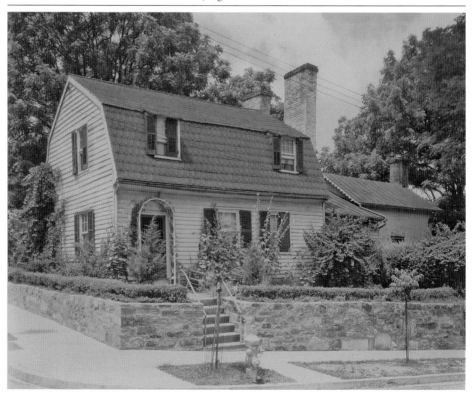

THE EARLIEST TIMES

This is one of the best-known historic homes in Fredericksburg. It was built in 1786 at 133 Caroline Street by Brig. Gen. George Weedon. The Sentry Box is described as a mid-Georgian-style home. Although lying directly across the Rappahannock River from where Union forces bombarded the city in December 1862, the Sentry Box survived the shelling. Considerable damage was sustained. It also survived the 1937 and 1942 floods. The Sentry Box is a popular stop on home tours. It is owned and occupied by a collateral descendant of General Weedon. (Above, VAL; below, TK.)

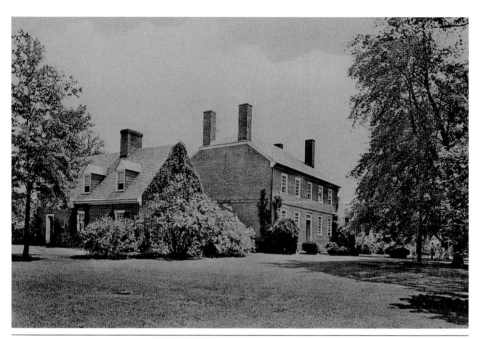

To most in Fredericksburg, this charming Colonial mansion built in 1775 by Col. Fielding Lewis for his wife, Betty, sister of George Washington, is known as "Kenmore." However, it did not become known by that name until the Gordon family acquired it in the 19th century. The Gordons' ancestral home in Scotland was known as "Kenmuir." In the 1920s, local developer E. G. Heflin owned Kenmore and envisioned it as apartments. That idea was quashed by a newly formed Kenmore Association, which stepped in to save the treasure. Today Kenmore, famed for its ornate plasterwork ceilings, is maintained by the George Washington Fredericksburg Foundation. It is open to the public much of the year. (Above, CRHC; below, HFFI.)

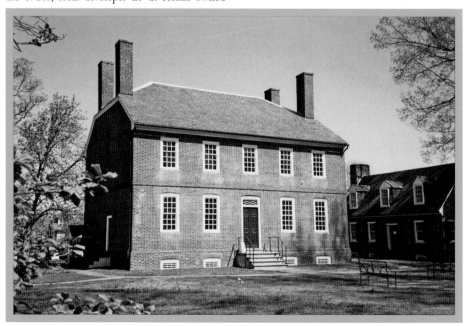

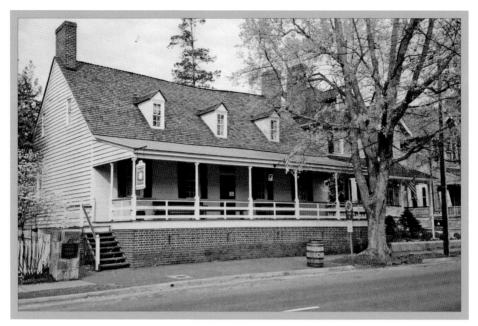

The Rising Sun Tavern has been known by several names since it first drew customers. George Washington's brother Charles built this as his home about 1760. When Charles moved to what is now West Virginia in 1792, a tavern was opened in this structure by John Frazier. It was called the Eagle. It was later known as the Golden Eagle and later still as the Washington Tavern. Eventually it became the Rising Sun Tavern. It is owned and maintained by the Association for the Preservation of Virginia Antiquities. (Above, HFFI; below, CRHC.)

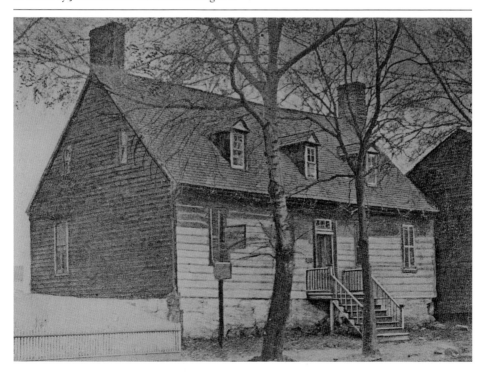

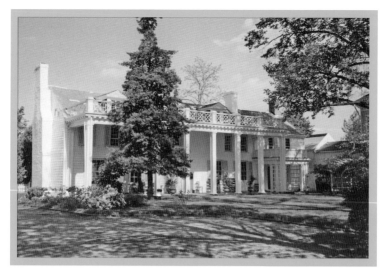

Located at 1107 Princess Anne Street, the Charles Dick house is one of the oldest homes in Fredericksburg. It was built in 1750. Charles Dick was a contemporary of George Washington, Fielding Lewis, and other patriots. Dick was co-commissioner with Lewis of the gunnery in Fredericksburg. Subsequent owners enlarged and modernized the original one-story home. The kitchen wing was added in 1802, and a second floor in 1808. The two-story portico was added in 1910 by John Masters. What is seen today as the front was originally the rear of the house. Before automobiles, gentry would arrive at the front door, where there was a spectacular view of the river. (Above, TK; below, HFFI.)

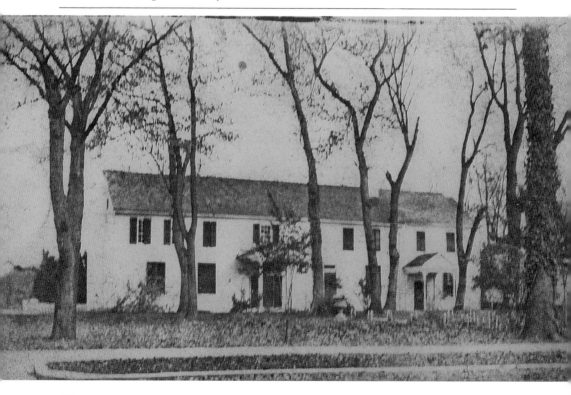

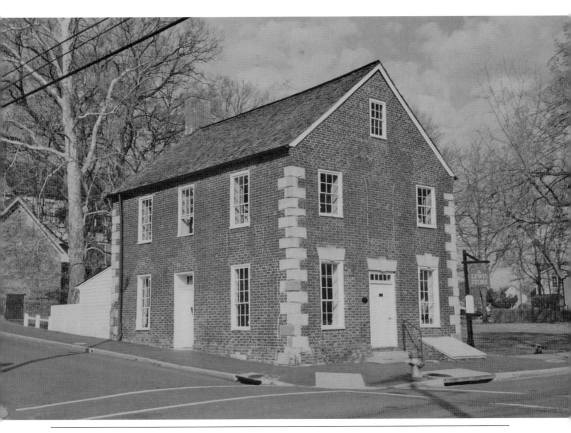

Located at 1200 Caroline Street, across from the regional library, the *c*. 1749 Lewis Store is said to be one of the oldest surviving commercial buildings in use in the commonwealth. The Historic Fredericksburg Foundation, Inc., maintains its headquarters here. The sandstone quoins are unique to this type of building. The store was built by John Lewis of Gloucester County, a prominent planter and merchant. Prior to the Revolution, his son Fielding Lewis conducted a retail business and had warehouses in Fredericksburg starting in the 1750s. (Above, CRHC; below, TK.)

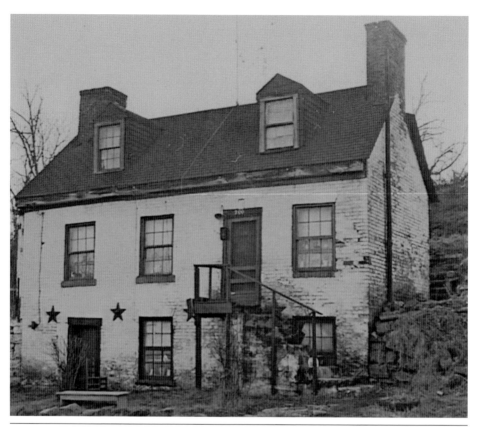

At the lower end of Sophia Street, bordering Rocky Lane, lies an early-19th-century, two-story cottage generally called the "Ferry Toll Keeper's Cottage." However, researchers have been unable to authenticate that claim. For the past 200 years, the tiny building has seen many uses. These included an office for a doctor, a grocery store, and a dwelling for a sea captain, but never a tollhouse. In the Civil War, Union troops laid a pontoon bridge across the river at this location. Floodwaters have also visited from time to time. The one-story brick kitchen wing was added in 1982. (Above, HFFI; below, TK.)

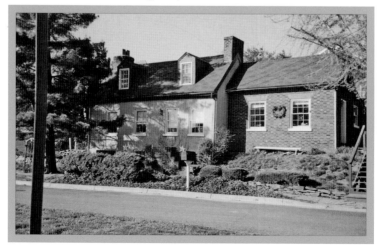

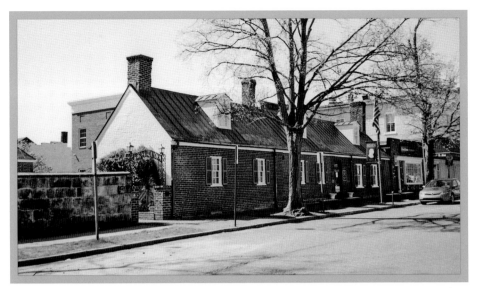

The Virginian who would become the fifth president of the United States owned the land upon which stands the James Monroe Law Library and Museum. However, he never practiced law in this pre–Civil War brick building. In 1927, Monroe's great-granddaughter Rose Gouverneur Hoes and her two sons created the law library and museum in this building. Their plan was to collect and save his documents, books, and artifacts, including his Louis XVI–style desk. The museum, located at 908 Charles Street, is administered by the University of Mary Washington and is open to the public. (Above, TK; below, HFFI.)

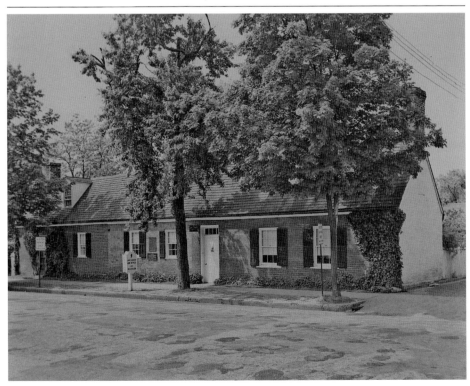

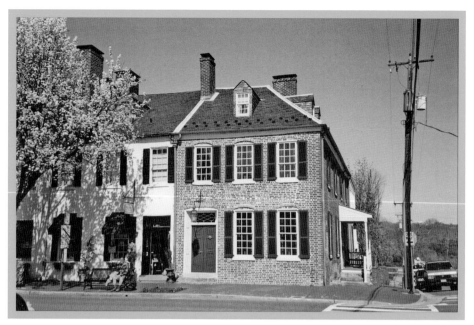

Finding housing in Washington, D.C., was extremely difficult during and after World War II. Like others, the Buffett family turned to Fredericksburg for a home. Surely, Warren and his sister Doris Buffett would have glanced at 701 Caroline Street. It might not have looked as good as this 1927 Library of Congress photograph. It remained in varying degrees of disrepair for several generations until philanthropist Doris Buffett purchased the property in recent years and restored it inside and out. Now it is a cornerstone of downtown Fredericksburg. (Above, TK; below, LOC.)

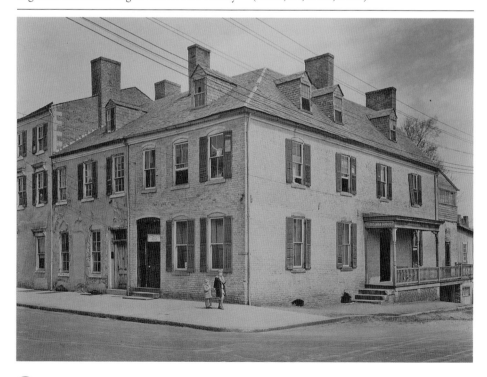

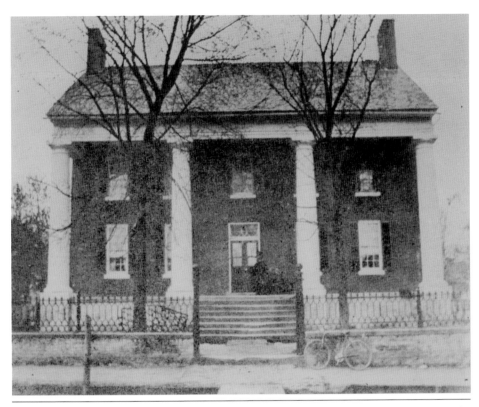

Smithsonia, at 307 Amelia Street, has been a Fredericksburg landmark for nearly 175 years. It was preceded on this site by a small Presbyterian church. That was demolished in 1834 to build the Female Orphan Asylum, funded by the church. During the Civil War it became a Union hospital, and later it became a boardinghouse for the elderly, run by Rebecca Smith—hence the name by which it is known now. It had also been used as a dormitory for Fredericksburg College. Smithsonia has been a private residence since 1915. (Above, HFFI; below, TK.)

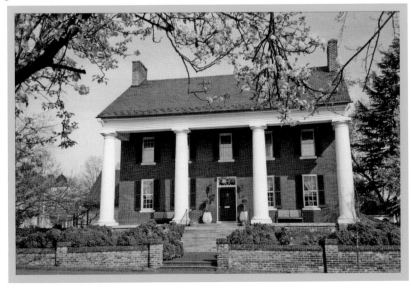

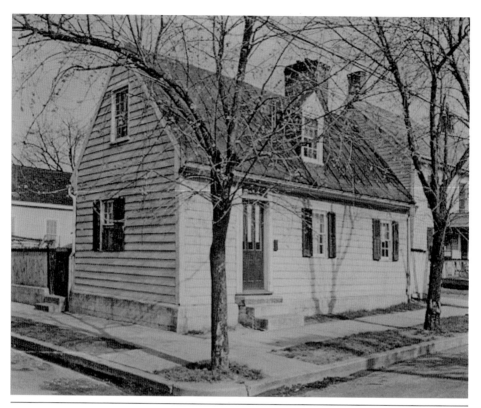

The rather quaint yet eye-pleasing cottage at 227 Princess Anne Street probably began as a stable for a home on the lot, which extends through to Caroline Street. The dwelling was built for John Green about 1814. The cottage caught the eye of Frances Benjamin Johnston in 1927. In the 1980s, the owners expanded this small historic home to its present dimensions. In doing so, the front entrance was moved to Princess Elizabeth Street. (Above, LOC; below, TK.)

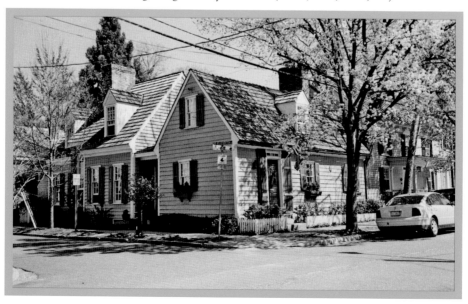

THE EARLIEST TIMES

Before this city hall was built in 1814, there was a town hall adjoining the market square directly behind here. It faced Caroline Street. This structure is on Princess Anne Street. The picture of city hall appeared in the 1907 special edition of the newly amalgamated newspapers the *Star* and the *Free Lance*. The accompanying article revealed that the city laid on a very elaborate welcoming celebration here for visiting General Lafayette in 1824. A century and a half later, the city vacated the building for new facilities at the former post office building. The post office was itself moving into new and larger facilities down the street. The old city hall at 907 Princess Anne Street was made available to the Fredericksburg Museum and Cultural Center. (Above, TK; below, FL-5.)

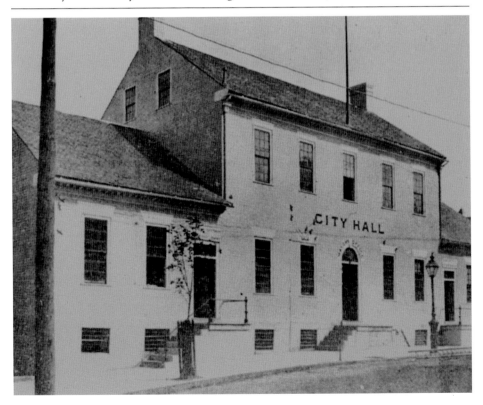

This area of downtown Fredericksburg was designated a public space back in 1728. It lies directly behind what was the old city hall. It has seen many uses through the ages. Farmers no longer bring their pigs, poultry, and produce to market. It is no longer used for parking, as it was for many years. The coveted space is managed by the Fredericksburg Museum and Cultural Center, which uses the old city hall itself. It is a popular venue for community and museum events in downtown Fredericksburg. (At right, TK; below, HFFI.)

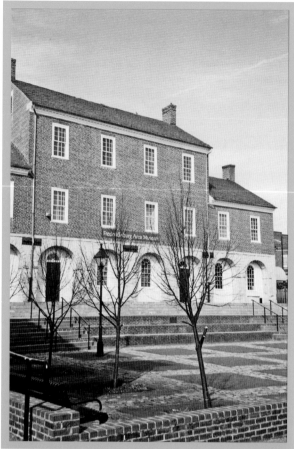

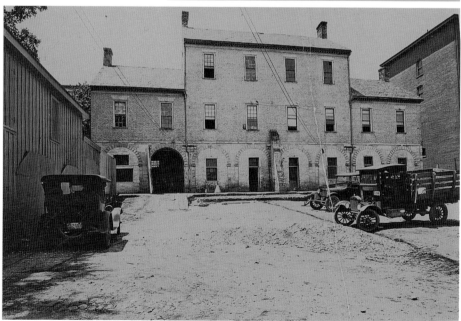

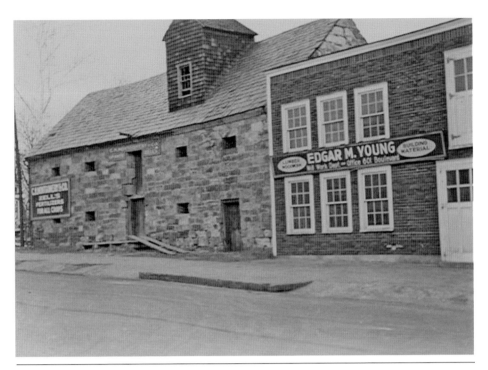

These two photographs of the Old Stone Warehouse at 923 Sophia Street show considerable change to the structure. Originally, it was constructed to defend the city from the British in the War of 1812. The Redcoats saw Washington as a better prize and bypassed the area, but Union forces in the Civil War did not. They shelled the warehouse and later used it as a morgue. Afterwards, it was used for storing fertilizer and also for curing fish. When a new Chatham Bridge was built, the level of Sophia Street had to be raised. The Old Stone Warehouse appeared to have sunk. (Above, CRHC; below, TK.)

On land owned by the Lewis family, Rebecca Tayloe Lomax erected this Federal-style building. The year was 1824. She lived here for almost 30 years. A century later, it became known as the Kenmore Tavern and then as the Kenmore Lodge. With a change of ownership, it became the Kenmore Inn. That's how it is known now. It has earned awards for fine dining and accommodations. It is located at 1202 Princess Anne Street. (Above, CRHC; below, TK.)

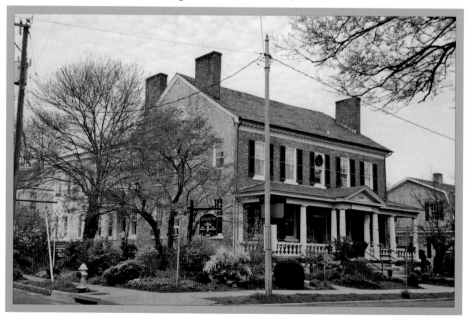

THE EARLIEST TIMES

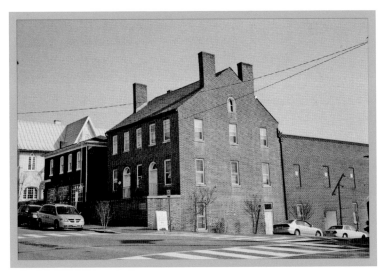

George Washington was inducted as a Mason into this lodge, No. 4 AF&AM, but not at this building at 803 Princess Anne Street. It was constructed in 1816, seventeen years after the president died. The Masons had met at various locations since the lodge's inception. This building was started by the Charity School, which didn't have the resources to finish it. The Masons came to the rescue and were rewarded with use of the upper floors. In 1910, they gained complete control and began a series of alterations. (Above, TK; below, CRHC.)

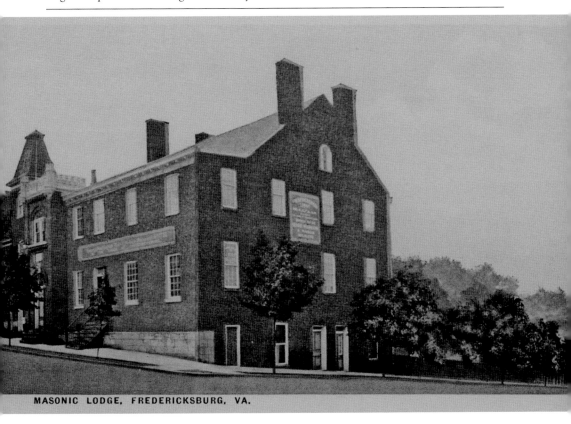

MASONIC LODGE, FREDERICKSBURG, VA.

Legends can be misleading. So it is with the pleasant little brick cottage at 209 Fauquier Street. In this case, it was never the home of Charles Washington, as some used to claim. According to the Historic Fredericksburg Foundation, Inc., the land on which it stands certainly was his. However, the house itself was not built until 1836 and then at the corner of Fauquier and Princess Anne Streets. This building was moved to its present location some 90 years later. A service station was constructed on the original site. (Above, TK; below, HFFI.)

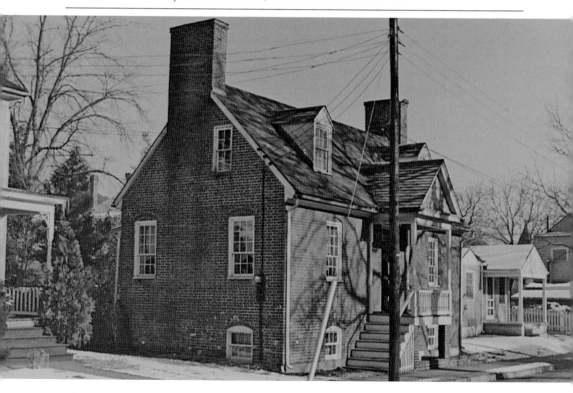

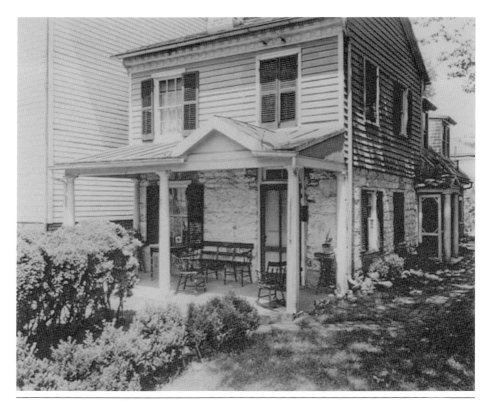

The small stone house at 1207 Prince Edward Street is one of the oldest buildings in Fredericksburg. When James Mercer bought the property from Fielding Lewis in 1769, the building was already on it, and evidence indicates that he used it as his study. The building gained a second story after the Civil War and was further expanded in the 20th century. (Above, LOC; below, TK.)

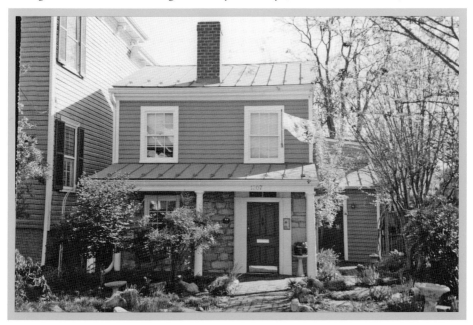

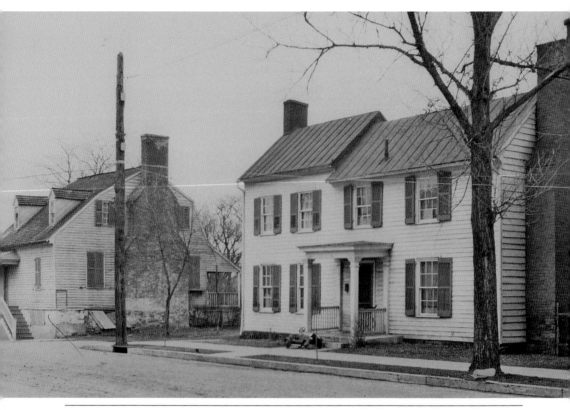

This building at 1213 Prince Edward Street was constructed about 1798 for John Dawson, a U.S. congressman known as "the poor man's friend." He obtained the property from the estate of James Mercer, who had lived nearby. The vintage image shows the neighboring home of Robert Forsyth, whose son John became a U.S. senator, governor of Georgia, and twice secretary of state under Presidents Andrew Jackson and Martin Van Buren. That home was demolished. (Above, LOC; below, TK.)

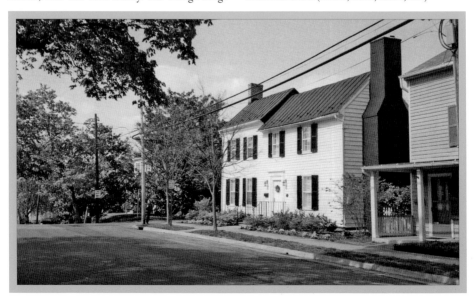

NEVER TO RETURN

This was never a beautiful and picturesque lane overlooking the Rappahannock River. Sophia Street was lined with the industry of pickle factories, canning plants, and hoop pole operations. Also there were the workers' homes and the tenements of those who toiled at the Bloomery Iron Works nearby. They're all gone now. Most were demolished before World War II. Even the retail stores that took their place in the 700 block have been torn down for construction of an attractive downtown riverfront park. (CRHC.)

This once-proud home at 1024 Princess Anne Street is no more. Many say it should never have been demolished for what others cited as progress. It was torn down to accommodate a drive-through banking facility. So where is the bank now? It too had to be removed to build a landscaped parking lot, shown above, for parishioners of the Fredericksburg Baptist Church across the street. The photograph of the home at 1024 Princess Anne Street was recorded by the Valentine Museum of Richmond in 1924. (Above, TK; below, VAL.)

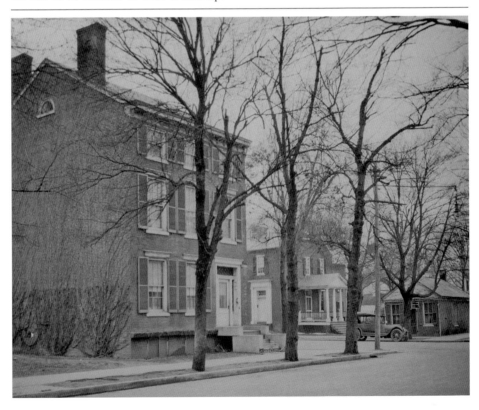

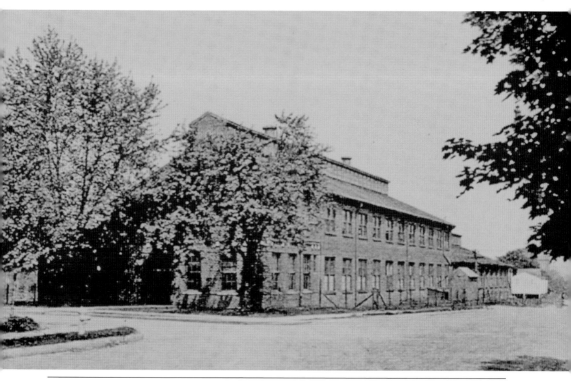

Two visionary out-of-state businessmen saw an opportunity and made an offer in 1889 to the Fredericksburg City Council. If the council would give them an acre of land and exempt them from paying taxes for 10 years, they would build and operate a silk throwing mill. There was agreement, and the mill began importing raw silk from Italy a year later. It was washed, dried, and spun into thread for manufacture. But 90 employees, mostly women and girls, lost their jobs when fire destroyed the mill in 1934. It was not rebuilt. A portion of the old structure remains along the 1700 block of Caroline Street. (Above, CRHC; below, TK.)

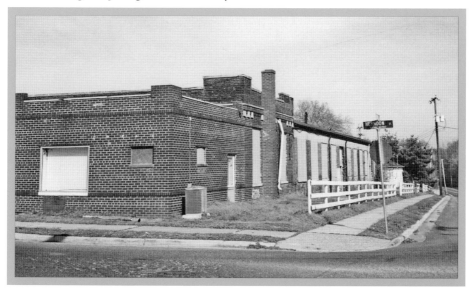

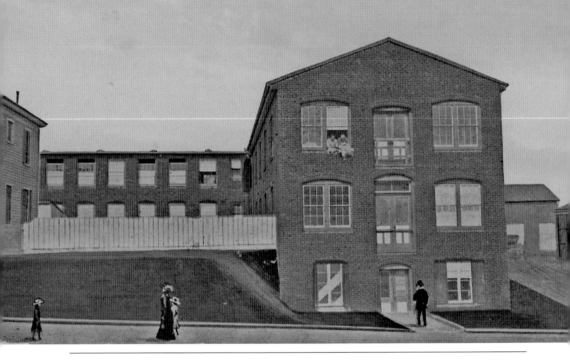

By the time this postcard was mailed in 1922, Washington Woolen Mills had been operating more than 60 years. When the Civil War approached, the Confederacy bought up as many army blankets as the mill could produce. In the conflict that followed, the factory suffered when the town was shelled. There was more trouble in 1910, when the manufactory was struck by fire. However, Washington Woolen Mills was rebuilt and prospered. The facility is now used by Dowling Signs. Adjacent homes were razed recently. (Above, CRHC; below, TK.)

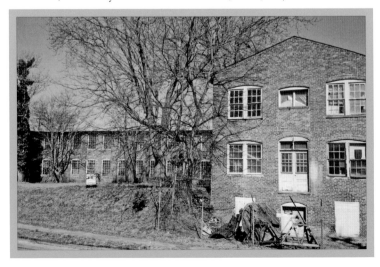

Long before the likes of Starbucks and other coffeehouses, tea shops were quite popular in Fredericksburg. One was Grandma's, which opened alongside the Mercer Apothecary on Caroline Street. Two ladies, Mrs. W. L. Browning and Mrs. D. W. Thompson, ran it until Benjamin Pitts said he needed the property to build his new Victoria Theatre. Eventually the movie palace couldn't compete with television, and it closed. The Fredericksburg Baptist Church took it over in 1988 and has used it ever since. (Above, TK; below, CRHC.)

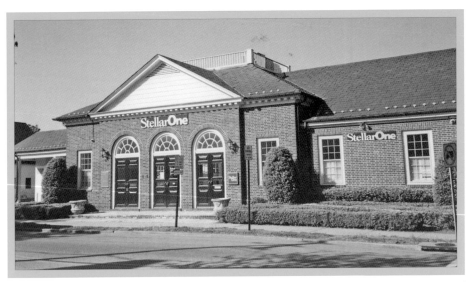

The current attractive brick building at 1018 Charles Street was the site of both a warehouse and the headquarters of Bridgewater Mills, which operated here from 1822 until 1908. It also served in the same capacity for the Rappahannock Electric Light and Power Company. Both were entities of the Ficklen family. There is an impressive and interesting plaque on the side of the building outlining these family enterprises. After those companies departed, the structure was demolished. The present building has been used by several banks, including the present occupant, Stellar One. (Above, TK; below, FLS.)

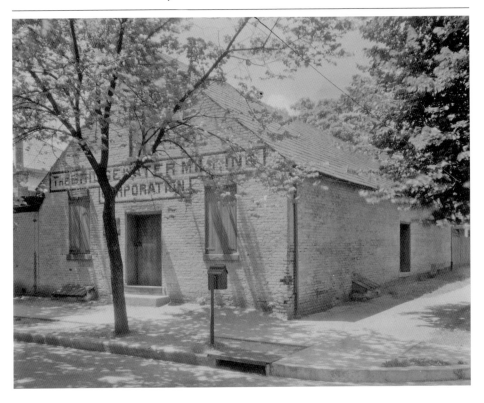

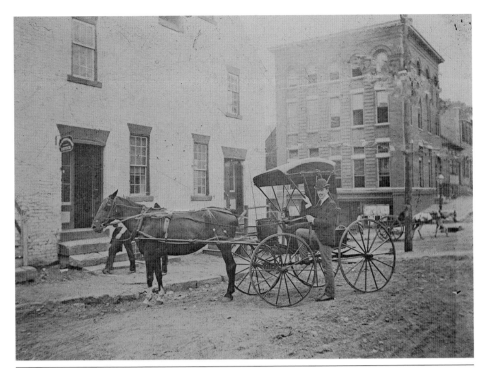

Apparently, the gentleman and his horse and buggy arrived at the lawyer's offices at the corner of Princess Anne and William Streets. This was 1901. The streets were unpaved. Years later, the office would be torn down to construct Planters National Bank, which opened in 1927, the first of several financial institutions to occupy the site. The Bradford building, seen in the background, was later demolished following a fire in 1963. The bank building is now home to the Fredericksburg Area Museum and Cultural Center. (Above, CRHC; below, TK.)

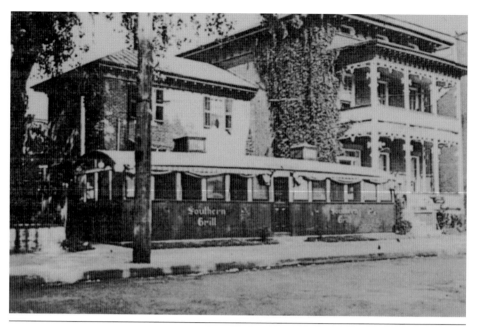

The Southern Grill and its next-door neighbor, the Colonial Inn, once were an integral part of the Princess Anne Street restaurant row in the 1000 block. Before the U.S. 1 bypass was built, Fredericksburg was the most desirable stop between Richmond and Washington, D.C. There were eating establishments here as well as hostelries of all calibers. For instance, the Colonial Inn bragged it offered hot and cold running water for the weary traveler. Both enterprises were demolished for the expansion of the Fredericksburg Baptist Church. (Above, HFFI; below, TK.)

The first Exchange Hotel in this city turned to ashes in a disastrous fire. Another arose to take its place in 1866 at the southwest corner of Caroline and Hanover Streets. Its proprietors proclaimed that it was the only first-class hotel here. Rates were a whopping $2 a day. The Exchange changed hands in 1915 to become the Frederick, and seven years later it became the Maury Hotel. It remained so until great changes took place downtown. The once proud Maury Hotel became extinct. The upper floors were transformed into apartments, while at street level, retail shops appeared along with a restaurant. (Above, TK; below, CRHC.)

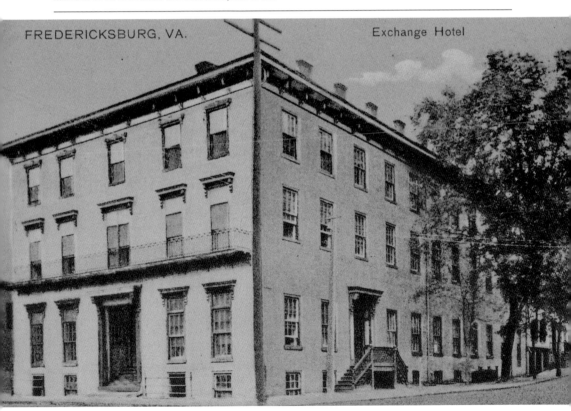

FREDERICKSBURG, VA. Exchange Hotel

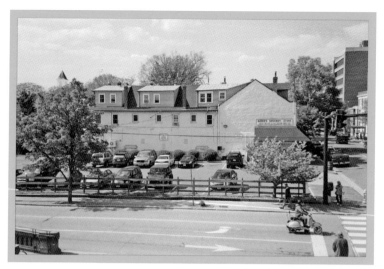

The Liberty Café and Confectionery was often described by the locals as the best place in town for refreshments, especially after church services on a Sunday. The Liberty boasted the first ice cream machine in town. This wondrous establishment was built in 1920 by James Calamos, a Greek immigrant. He installed his brother Nick as proprietor. Since then, there have been many Calamos family restaurants in Fredericksburg. Sadly, the Liberty, across from the train depot, has disappeared as surely as ice cream on a hot summer day. The location has become a parking lot for a Caroline Street grocery store. (Above, TK; below, CRHC.)

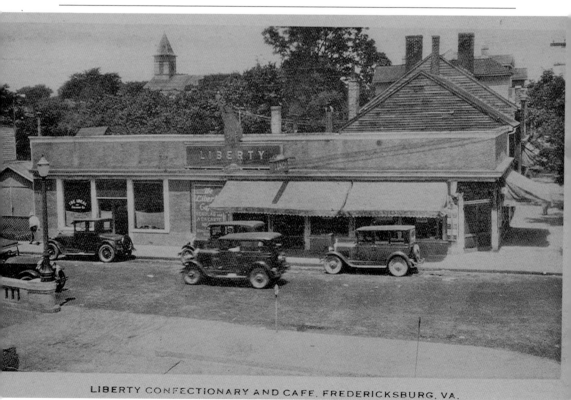

LIBERTY CONFECTIONARY AND CAFE, FREDERICKSBURG, VA.

NEVER TO RETURN

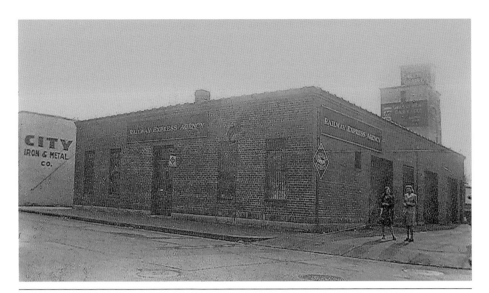

Before the advent of UPS and FedEx, there was REA, the Railway Express Agency, to deliver packages. This was the agency's Fredericksburg facility, next to the tracks and station of the RF&P RR. The one-story brick building is of 1927 vintage. REA declared bankruptcy in 1971. The building fell into disrepair until local businessman Joe Wilson saw its potential. Today it holds the offices of the George Washington Commission, a vibrant local economic development organization. (Above, JW; below, TK.)

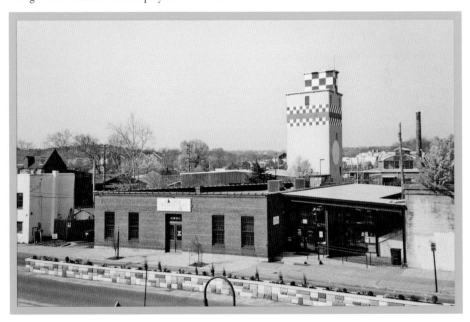

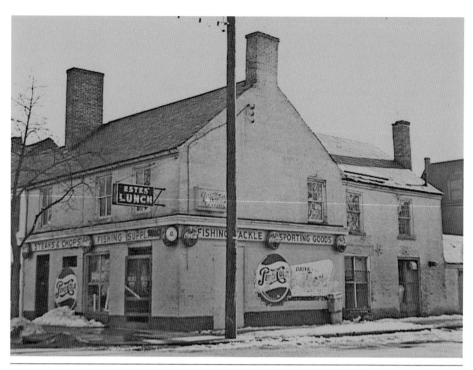

Examining the intersection of Princess Anne and Frederick Streets today, only a few natives and historians are likely to know that this was once a busy neighborhood. The vintage photograph shows Estes Fishing Tackle and Lunch, formerly the African American–owned Tate Drug Store. On the opposite corner at 317 Princess Anne Street was the Spot Restaurant. Since this image was taken in 1924, the area has become less desirable for business and become more residential. Being close to the train station, it has attracted commuters. (Above, VAL; below, TK.)

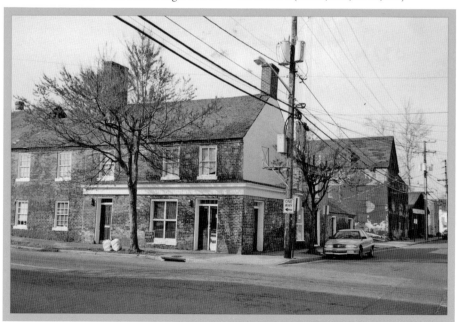

The Spot Restaurant and Estes Fishing Tackle sat across the street from one another at the intersection of Princess Anne and Frederick Streets. On the east side was the Spot, and on the west was Estes, formerly Tate's Drug. This was a friendly and fairly prosperous neighborhood near downtown. When many of the big-name stores departed for the new mall in the 1970s this neighborhood declined. Both the Spot and Estes have reverted to residences favored by commuters. (Above, TK; below, HFFI.)

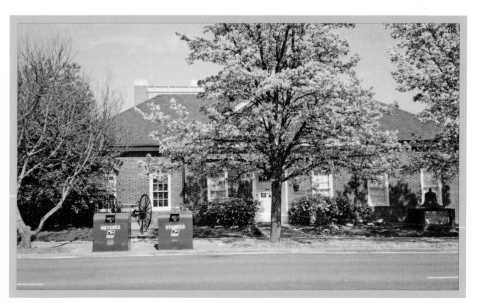

This two-story brick structure at the corner of Princess Anne and Wolfe Streets was the Fredericksburg Colored School. Built in 1884, it was quite small, having only four classrooms for students through the seventh grade. At the time, the area had many businesses and hotels catering to blacks. Shiloh New Site Baptist Church was just across Wolfe Street. The Colored School was torn down to build a bus depot and later, a fire station. (Above, TK; below, FLS.)

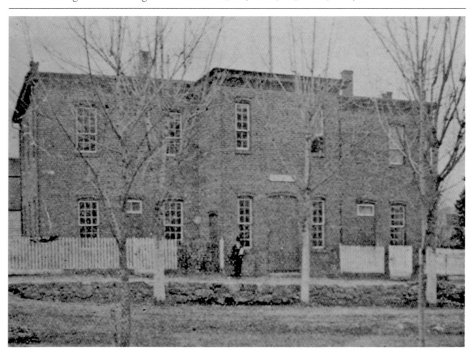

Along Sophia Street, beyond assorted factories and canning sheds, lay several structures in varying degrees of deterioration. Some were dwellings of those who labored nearby. This shows the east side of the 700 block of Sophia. Over time, decay took its toll, and the blighted area had to be razed. Most of it was done before World War II. Afterwards, retail establishments sprang up. Now they too are gone. The city acquired some of this valuable downtown property to build a tourist-friendly riverfront park. (Above, HFFI; below, TK.)

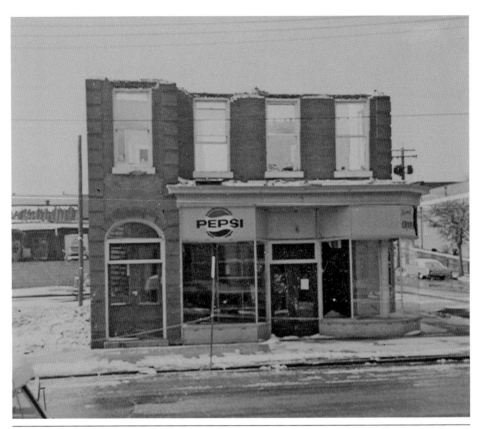

Downtown, at the corner of Caroline and Charlotte Streets, stood one of many friendly neighborhood grocery stores. This was Noodles, run by Arthur and Grace Cox. It had to be torn down to accommodate a municipal parking lot for a new police and fire department headquarters nearby. More changes were to come later. The parking lot and a small building next to it became redundant in order to build a much needed downtown hotel, the Courtyard by Marriott. It opened in 2009. The visitors center is conveniently close. (Above, HFFI; below, TK.)

NEVER TO RETURN

This view from the Purina grain tower shows the Fredericksburg gas plant, the RF&P railroad tracks, and the depot, turntable, and engine house of the narrow-gauge Virginia Central Railroad. It operated over 38 miles from the city to Orange. The railroad ceased operations in 1984. The tracks were torn up, but the station remained. The building served as a propane gas distributorship and later as a real estate office before becoming home to a succession of restaurants. The latest has an Irish theme. (Above, TK; below, LD.)

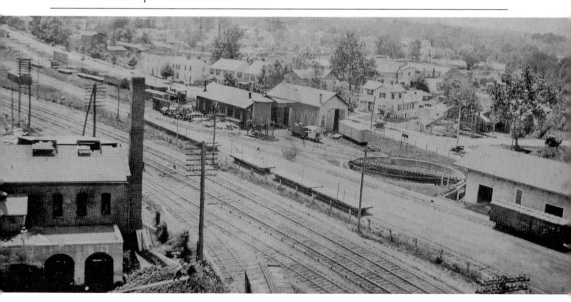

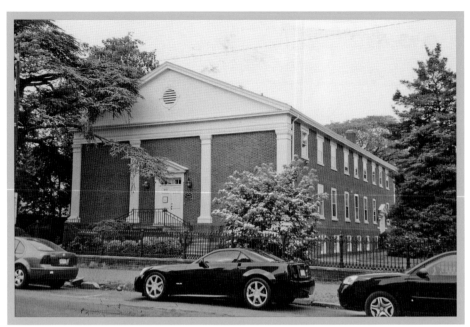

It had been theorized that because the French Memorial Chapel was made of gray granite it could never burn down. That was proven wrong on a January afternoon in 1954. A faulty furnace in the basement caused a fire that engulfed the floor above and also destroyed three valuable Tiffany stained glass windows. The building was a complete structural loss and had to be razed. The Presbyterian Church replaced the memorial chapel with a brick educational building. (Above, TK; at right, CRHC.)

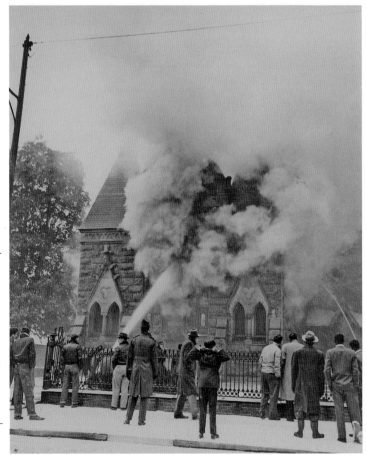

TRANSITIONAL

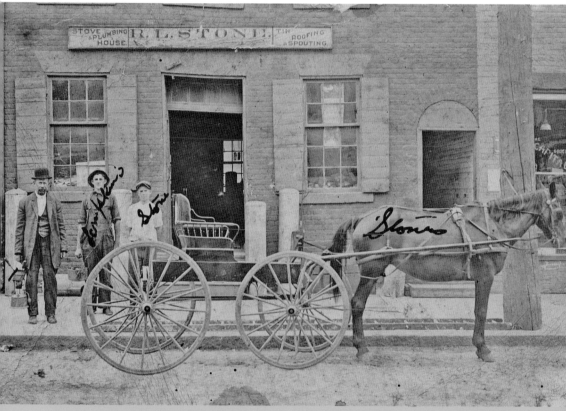

Through the years, many of Fredericksburg's tradesmen's buildings have vanished. One example is R. L. Stone, Plumbing and Tinning. Stone's business at 412 William Street was a community fixture from the beginning of the 20th century until the 1920s. There is no record of Stone's service charge for a house call with his horse-drawn cart. Here, Stone is on the left and his son on the right, with a helper in the middle. The building and others in the block were demolished after a disastrous fire in 1972. The area became a large parking space. The address is now a driveway for Virginia Partners Bank. (CRHC.)

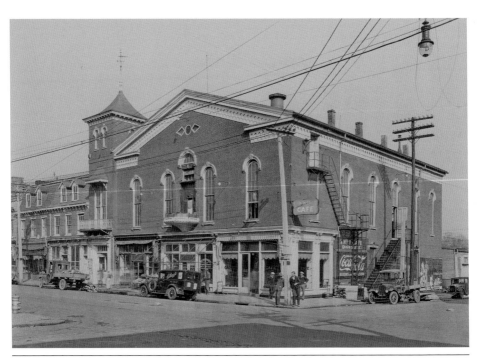

This picturesque opera house in downtown Fredericksburg didn't survive the wrecker's ball very long. Constructed in the 1880s on the site of Weedon's Tavern, which burned in the fire of 1807, it became a popular entertainment palace. However, it was demolished in the 1950s for construction of a Woolworth's. In its heyday, the opera house provided a variety of entertainment from vaudeville to Tom Thumb weddings, the John Philip Sousa Band, and minstrel shows. Presidents William McKinley and Grover Cleveland were welcomed here. When Woolworth's departed, 1001 Caroline Street became a large antique mall. (Above, HFFI; below, TK.)

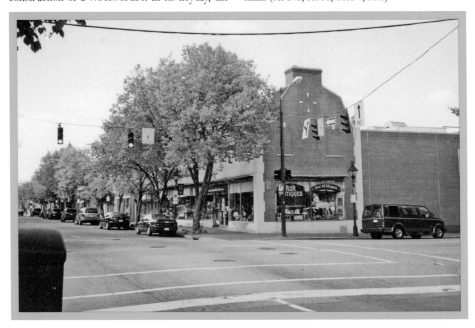

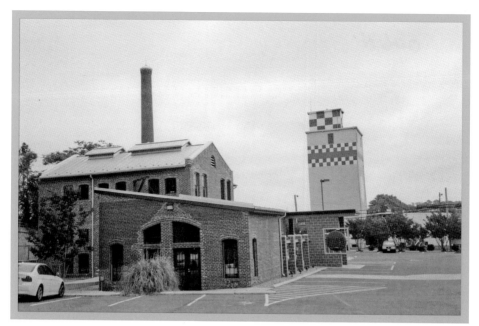

This was the gasification plant constructed in 1900 to provide gas for Fredericksburg's street lamps and later for home use. The plant remained in operation until just after the end of World War II. Efforts to convert the plant for propane use were abandoned when a tank exploded and started a fire, forcing the evacuation of a 12-block area in adjacent downtown bordering the railroad depot. The shell of the abandoned gas plant remained an eyesore for many years. Eventually, local contractor Thomas J. Wack reached an agreement with the city to rehabilitate the building to the modern offices seen here. (Above, TK; below, CRHC.)

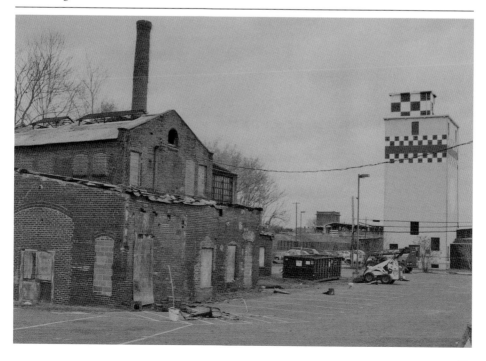

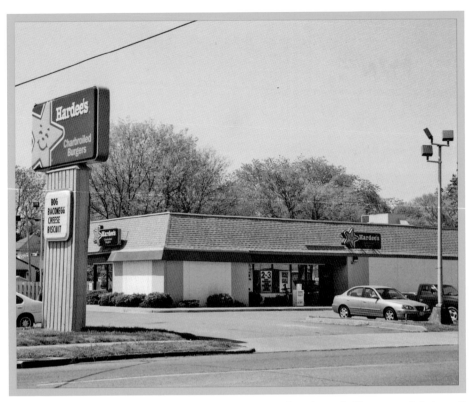

In the late 1920s, Karl Herr, proprietor of the Princess Anne Café, stood with his foot on the running board of his new automobile. The café was located at 1700 Princess Anne Street, on the main corridor of Highway 1 through town, a popular midway stop between Washington, D.C., and Richmond. Herr expanded the café into a friendly 50-room hotel he named the Mary Washington, boasting shower baths and garages for 20 automobiles. Sale by Herr's heirs and two fires ended the business. Hardee's now stands on the site. (Above, TK; below, CRHC.)

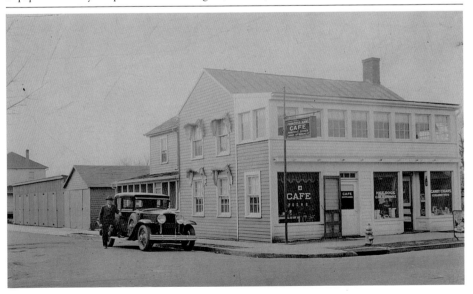

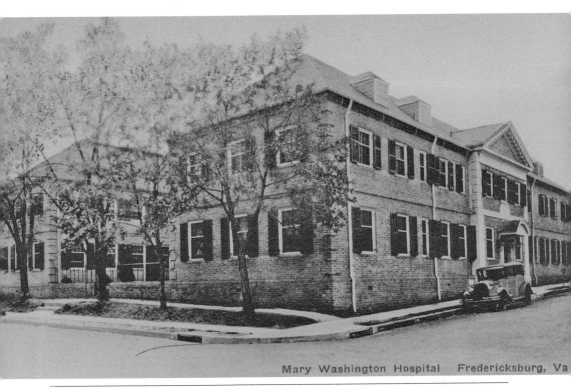

Mary Washington Hospital Fredericksburg, Va

This was the second hospital built at the corner of Sophia and Fauquier Streets overlooking the Rappahannock River, a tranquil site. The year was 1928. The new Mary Washington Hospital boasted 50 beds. However, increasing admissions forced expansion to a new and bigger facility on Fall Hill Avenue, and then later to a huge medical campus on the hills of the former Snowden Farm. The facility on Sophia was converted for residential living. (Above, CRHC; below, TK.)

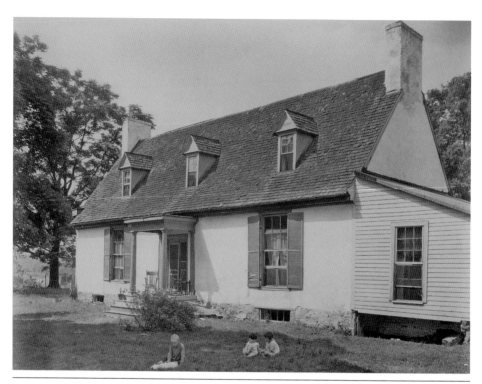

The quaint 18th-century cottage seen here was named "the Falls" by its builder, Col. Francis Thornton Jr. (1710–1749). The cottage was demolished by E. G. "Peck" Heflin in order to construct his majestic Stratford Hotel. The year was 1931, the early days of the Great Depression. Heflin was persuaded to save the Thornton Cemetery behind his hotel, where it remains. In 1975, it was deeded to the City of Fredericksburg, which cares for it. The Stratford later became the George Washington Inn. Its restaurant was immensely popular. When motorists used the bypass more, Route 1 through town became less busy, and the hotel closed its doors. The building was saved and converted to office suites. It is now the George Washington Executive Center at 2215 Princess Anne Street. (Above, LOC; below, TK.)

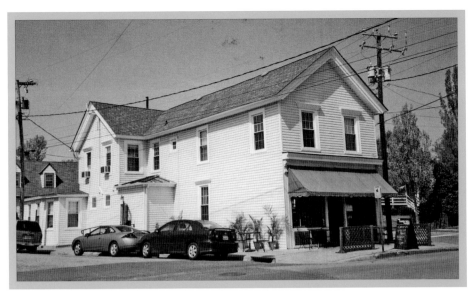

Native Fredericksburger George Freeman Jr. set up his grocery business at the corner of Littlepage and Hanover Streets as the 20th century dawned. He promised quality and service, in which he excelled. He delivered groceries to customers' homes, first by horse and cart and later by a fleet of trucks and vans. He also sold such diverse products as hay and grain as well as railroad ties, possibly Civil War surplus. After the store closed, it was succeeded by other businesses, including a sandwich shop. Today it is the popular Sunken Well Tavern. (Above, TK; below, CRHC.)

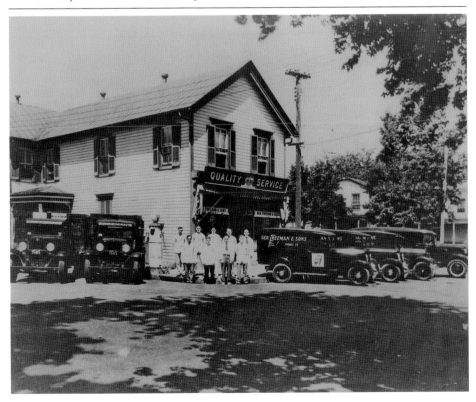

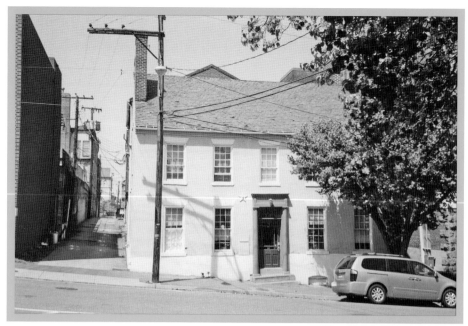

Records reveal that a small charity school was established in 1759 in the 200 block of Hanover Street, just below where the Masonic lodge building now stands. The school building, which survived into the 1920s, was also used by the Christian Science Church but was demolished for expansion of the Masonic lodge in 1916. Miss Willie F. Schooler's Hanover School conducted classes in the adjacent brick building across Jail Alley. When that school closed, the Greek immigrant Pappandreou family bought the property and it became the annex to their hotel on the corner of Hanover and Caroline Streets. (Above, TK; at right, FLS.)

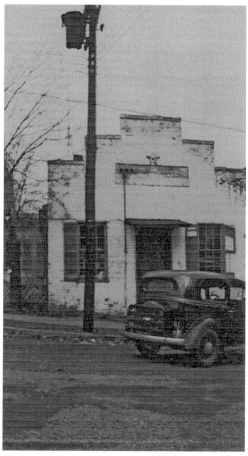

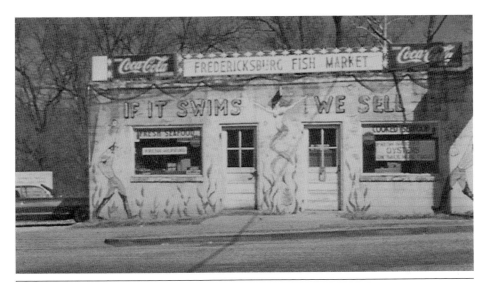

"If it swims we sell it," proclaimed this purveyor of all things finny. Just over the Chatham Bridge, around the corner of Sophia Street, stood one of Fredericksburg's many fresh fish markets in the post–World War II era. This photograph of the gaily colored exterior of the market at 1005 Sophia Street was recorded for posterity by the late local historian, Ralph Happel. This building on the site most recently served as a hair salon. (Above, CRHC; below, TK.)

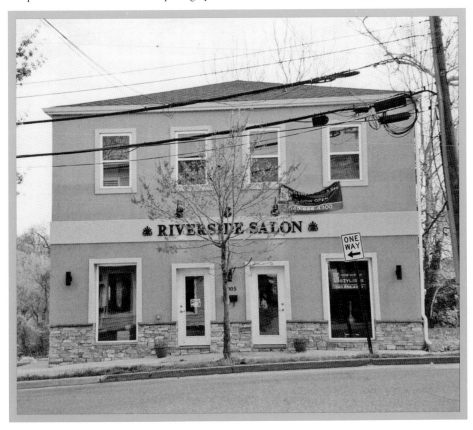

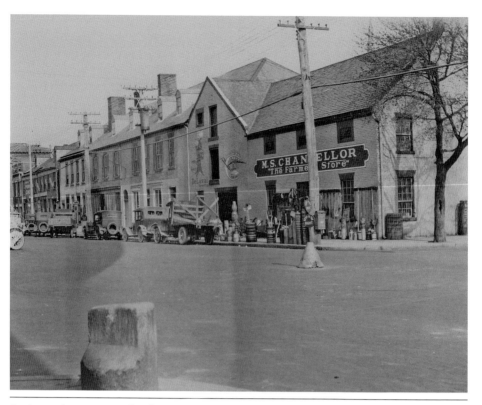

At the southeast corner of William and Charles Streets lay the M. S. Chancellor Farmers and Agriculture Supply Store. This Valentine Museum photograph of 1924 provides a fascinating glimpse of everyday life in the city. Note Chancellor's wares displayed on the sidewalk. Telephone lines are not yet underground; note the traffic-control pylon in the intersection. The buildings were demolished in 1957. Fifty years later, Castiglia's Italian Restaurant occupies the William Street corner at Charles Street. (Above, VAL; below, TK.)

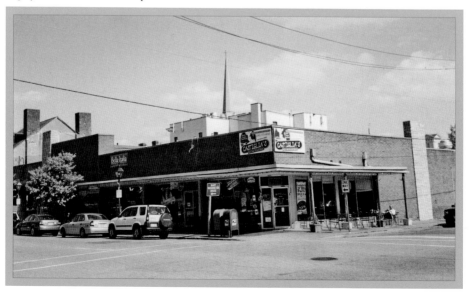

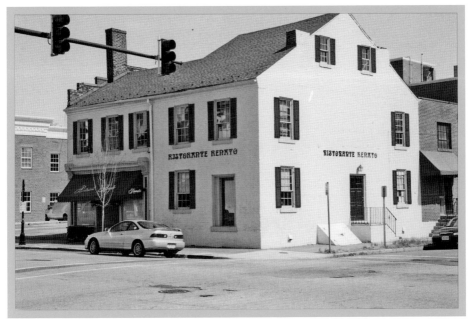

Change has been good, especially when describing the pre–Civil War building at 426 William Street, at the corner of Prince Edward Street and across from Hurkamp Park. This is a site that has seen many uses. As one can see in the early photograph by Francis Benjamin Johnston, it was a fertilizer warehouse. The Virginia Shoe Company had an office and showroom here. This building and the one next door survived a fire in 1972 that destroyed much of the same block. Now this is Ristorante Renato, a popular ethnic eatery. (Above, TK; below, LOC.)

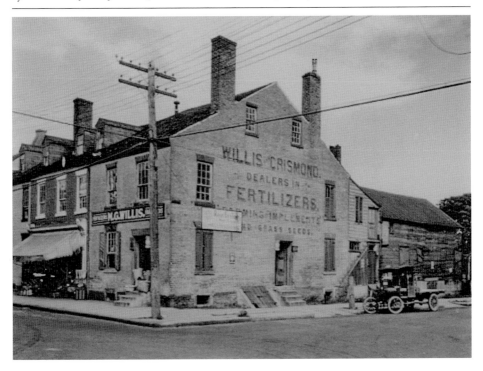

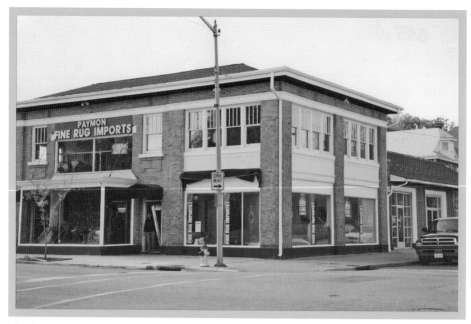

This business at 501 William Street had over 15,000 square feet of warehouse space used for groceries and automobile tires. That sums up its history. Simon Hirsh and Brother was a successful wholesale grocer when this photograph was taken in 1907. It was displayed in the first special edition of the combined *Star* and *Free Lance* newspapers. The Hirsh building was demolished to erect a Firestone Tire store. Now it is home to Paymon Fine Rug Imports. (Above, TK; below, FLS.)

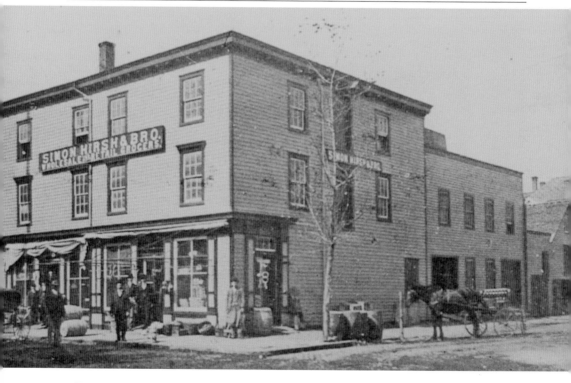

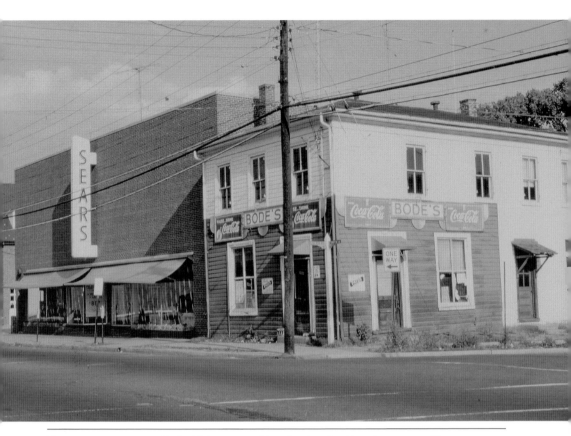

Not very many years ago, Fredericksburgers could shop at a number of chain and department stores downtown, including nationally known ones: J.C. Penney, Woolworth's, Western Auto, Montgomery Ward, Leggett's, People's Drug, and Safeway. Sears Roebuck erected a store at 520 William Street on the site of a Masonic cemetery. The graves were moved to the Charles Street Masonic Cemetery. Next to Sears for a while was Bode's Café, shown here. It was demolished to create a parking lot. The Sears building has become a real estate office. (Above, CRHC; below, TK.)

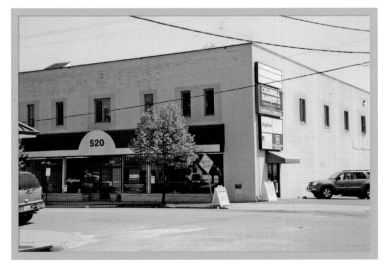

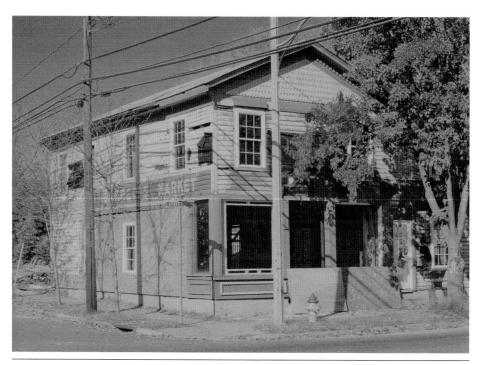

In the early years of the 20th century, Fredericksburg seemed to have a neighborhood market wherever one turned. At the edge of town was the Garrett Market at 915 Prussia Street. In World War I, this thoroughfare became National Boulevard, and later still it became Lafayette Boulevard. Records of the store reveal that like many competitors, Garrett sold hay and feedstuffs to bolster the bottom line. The Garrett Market finally closed. The building has been restored and then remodeled to house an art gallery. Two apartments are attached. (Both, TK.)

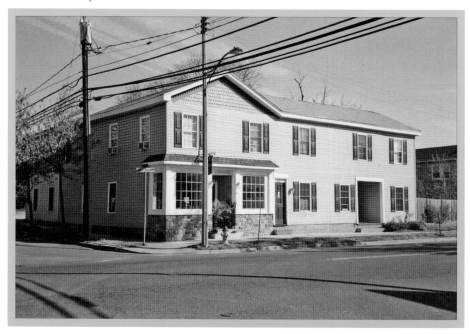

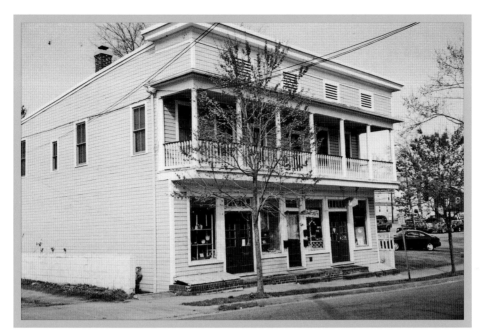

Entering the city over the Chatham Bridge, it is surprising to come across what appears to be a New Orleans–style, two-story building at 1006 Sophia Street. For over 30 years beginning in 1922, this was a destination for raw bar devotees. It was Matt Buckner's Sea Food Lunch, a legendary business known for its oysters. The highly successful Buckner was black, his customers white. This was at a time when segregation was rampant. He lived in Gloucester County. As soon as there was an "R" in the month in the fall, Buckner would come here to open his restaurant for the oyster season. Since 1956, many businesses have operated here. (Above, TK; below, HFFI.)

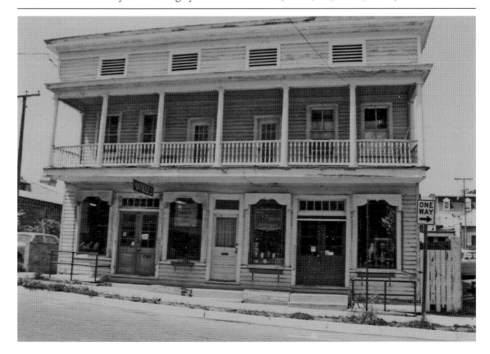

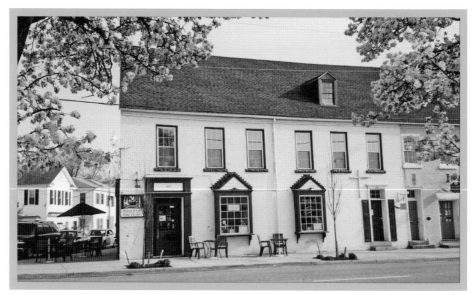

For generations, this building at the southwest corner at William and Liberty Streets was a popular tavern. It was close to the area known as "Wagon Town." Eugene Bode (pronounced *boo-dee*) ran a watering hole praised for its Virginia hospitality. By 1907, Bode was gone, killed in a railroad accident. His widow, two sons, and a brother-in-law continued the business. Eventually the Bodes moved across the street. Scotty's Pastry Shop opened at the old location and prospered many years. Now it is Primavera Pizza. (Above, TK; below, HFFI.)

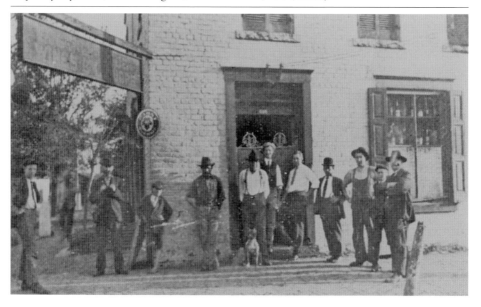

TRANSITIONAL

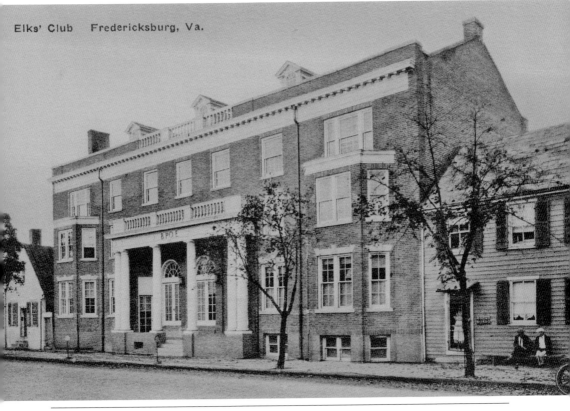

Elks' Club Fredericksburg, Va.

The Benevolent and Protective Order of Elks Lodge 875 is an imposing structure at 525 Caroline Street. It was built in 1924, incorporating a much smaller Elks lodge on the site, and was enlarged again 12 years later. A further 60 years after that, the Elks moved out of town and sold the property, making way for Fredericksburg Square, home to Albertine's, a first-class restaurant. In recent years, there has been speculation that 525 might become condominiums or a hotel. Meanwhile, it has become a venue for special events. (Above, CRHC; below, TK.)

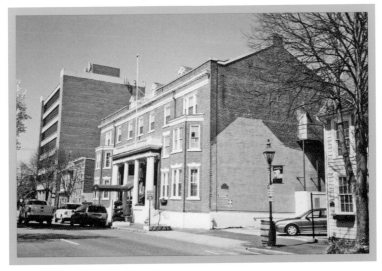

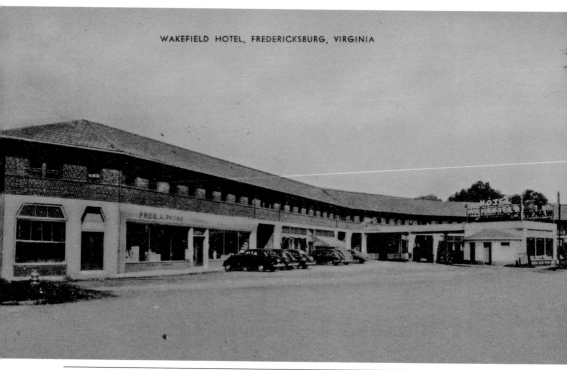

WAKEFIELD HOTEL, FREDERICKSBURG, VIRGINIA

Encompassing the 1700 block of Princess Anne Street, this was one of the very first motor hotels. The Wakefield Inn was constructed by E. G. "Peck" Heflin on the then-busy and vital Highway 1 corridor through town. It was designed to accommodate the traveler and featured a gas station, café, and shops. This was a great stop for tourists, but the allure faded with increasing use of the bypass. The inn changed hands and became the Fredericksburg Colonial Inn, featuring rooms decorated with antiques. Now it's known as the Inn at the Site of the Old Silk Mill, after a factory that operated until 1934 at the rear of this property. (Above, CRHC; below, TK.)

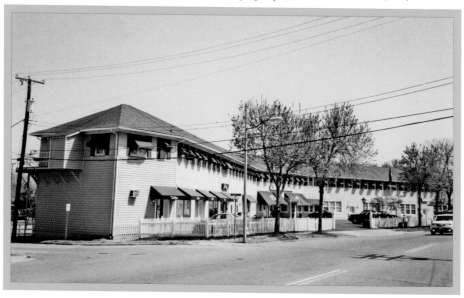

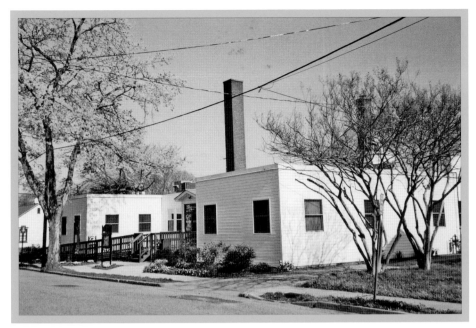

Shortly before the United States entered World War II in 1941, the Fredericksburg City Council was deliberating building a teen center. However, the war changed everything. The government decided to create a series of clubs for servicemen and women. Almost overnight, USOs sprang up near military bases. This one at 408 Canal Street was dedicated on Valentine's Day, 1942. It proved extremely popular. Civilians donated time and service. Once the war was over, the USO departed. The city now uses it as the Dorothy Hart Community Center. (Above, TK; below, CRHC.)

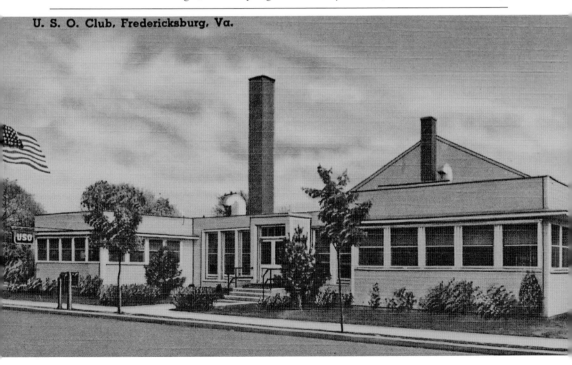

U. S. O. Club, Fredericksburg, Va.

James Renwick Jr., who famously designed the Smithsonian Institution castle, was also the architect of the Fredericksburg Court House, built in 1852. This replaced the original 1740 courthouse. The city incorporated the fire station in part of the structure. It is located at 815 Princess Anne Street. During the Civil War, Union troops found the courthouse tower excellent as a signal station. They also made use of the building as a jail and a hospital. The 1828 bell cast in Boston's Paul Revere Foundry was moved into the new courthouse. (At right, TK; below, TK.)

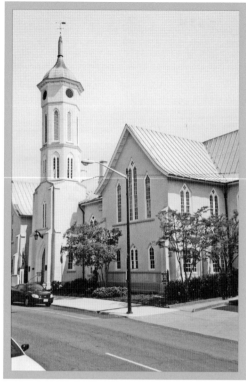

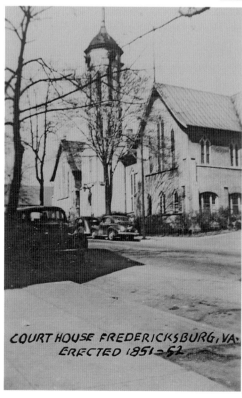

COURT HOUSE FREDERICKSBURG, VA.
ERECTED 1851-52

Then and now photographs of downtown showing the east side of Caroline Street over a span of 50 years illustrate dramatic change. These are the facades of buildings located at 917, 919, and 921. None of the businesses shown in the early photograph survived the turbulent intervening years. Now different owners conduct their businesses at attractively remodeled buildings in a different and visually pleasing downtown. These are the first buildings of the 21st century on Caroline Street. (Above, HFFI; below, TK.)

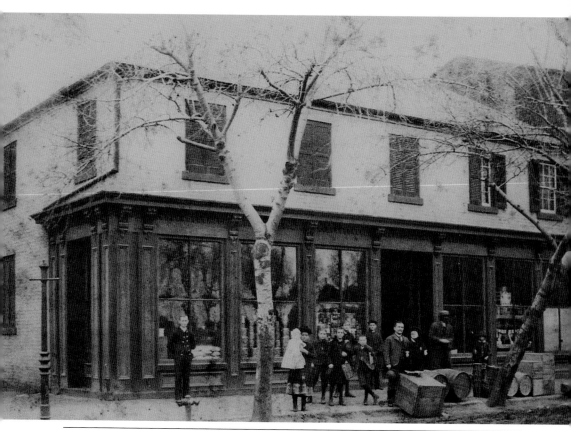

This decidedly modern two-story building at 600 Caroline Street is occupied on the ground floor by Salono hair salon, while upstairs is the domain of architect James McGhee who constructed it. Around 1900, when streets of Fredericksburg were still unpaved, John Michael Griffin's grocery store stood on this site. It began when the nearby colored school was demolished to pave way for a new city fire station and headquarters. (Above, CRHC; below, TK.)

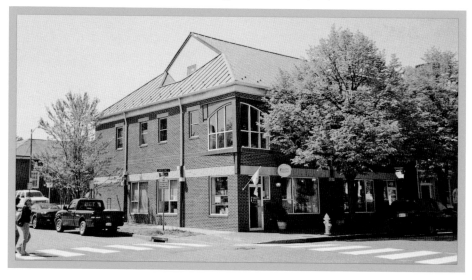

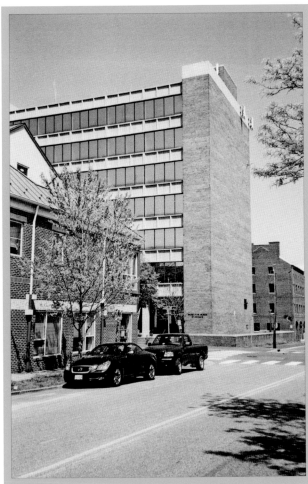

Many citizens marveled at the new Executive Plaza when it became the tallest building downtown and forever changed the city's skyline in 1974. Others were disenchanted and quickly criticized its design as lacking local harmony. It became the catalyst for reform of architectural standards citywide. Not surprisingly, 601 Caroline Street earned the sobriquet "Big Ugly." However, the J. W. Masters lumberyard and salesroom it replaced was no beauty either. The city bought the building in 2003 for office space. (At left, TK; below, CRHC.)

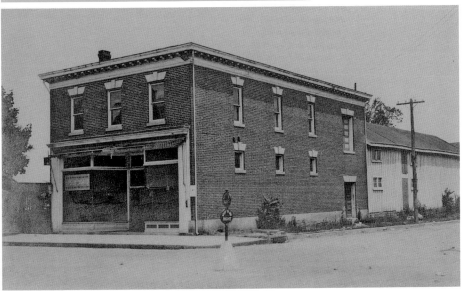

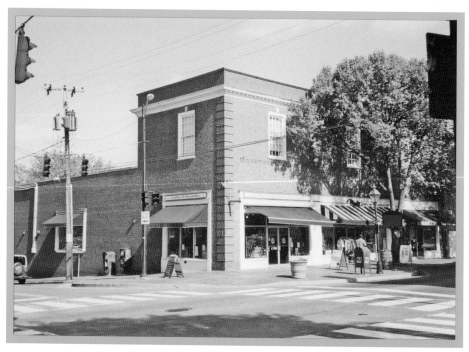

For more than half a century, there was an M. M. Lewis Drug Store in Fredericksburg. The first opened in 1885 at 829 Caroline Street. In 1917, it moved to 301 William Street at the corner of Princess Anne Street. That's where Hyperion Espresso does business today. Lewis Fountain Service, operated by M. M. Lewis Jr., opened at 415 William Street. The original drugstore and two other buildings were razed to construct a J.C. Penney in the 1950s. Penney's departed when many stores left downtown for a new mall. The spaces were remodeled for smaller retail businesses. (Above, TK; below, CRHC.)

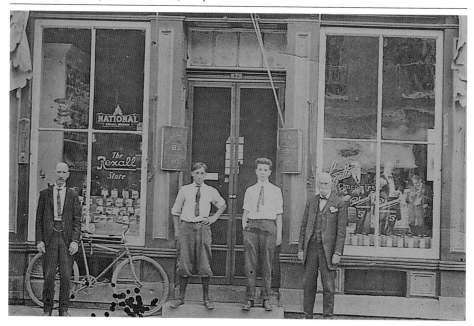

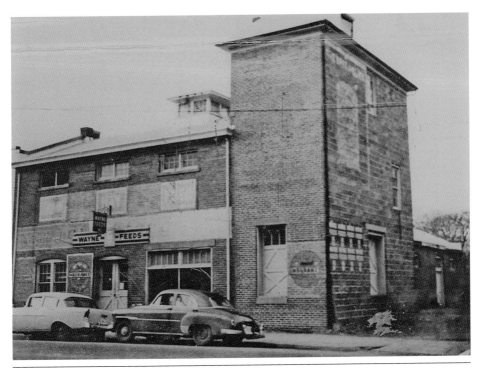

Fredericksburg Hardware was a friendly small-town store for nearly a century. It opened in 1914 in the building that now houses La Petite Auberge restaurant, selling mostly agricultural goods such as horse collars, buggies, and wagons. The store made a final move in 1959 to 513 William Street, the former home of Wayne's Feeds, seen here. The advent of big box stores helped bring about the demise of Fredericksburg Hardware in 2004. The building now is slated to be razed and replaced by luxury town houses and a mixed-use commercial building, which might include a performing arts theater. (Above, CRHC; below, TK.)

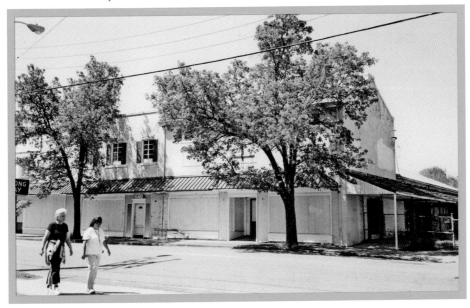

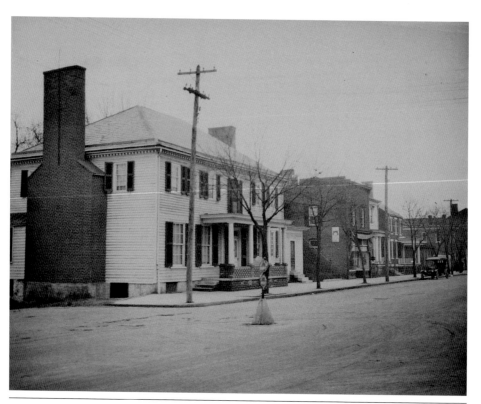

Scottish immigrant John Glassell constructed his home at 623 Caroline Street in 1772. This attractive building in the heart of downtown has seen many owners but few changes to the exterior. The property has had diverse tenants, including the Fredericksburg Museum, run by Historic Fredericksburg Foundation; a restaurant featuring French cuisine; and a bakery and cake shop. Throughout the years, it's almost always been referred to as the Chimneys. One glance at its north side shows why. (Above, VAL; below, TK.)

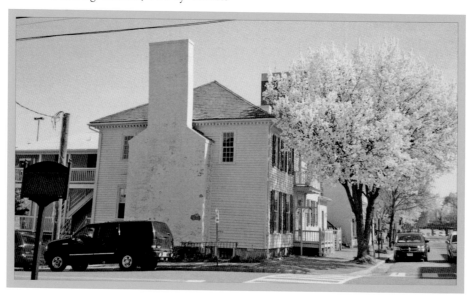

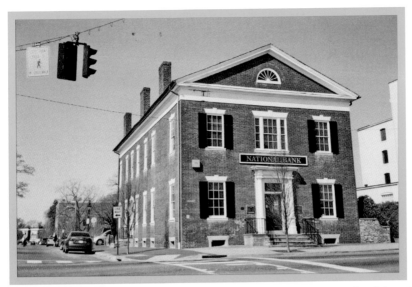

This splendid building at the corner of Princess Anne and George Streets was erected in 1820 for the Farmers' Bank of Virginia. The bank cashier lived upstairs. Dabney Herndon was the first cashier. The Herndon family owned a young slave named John Washington who wrote *Memorys of the Past*, describing his life in Fredericksburg before and during the Civil War. After the war, Farmers' became the National Bank of Fredericksburg, a name retained by its most recent owner, PNC Bank, which also maintains a museum of banking artifacts here. (Above, TK; below, CRHC.)

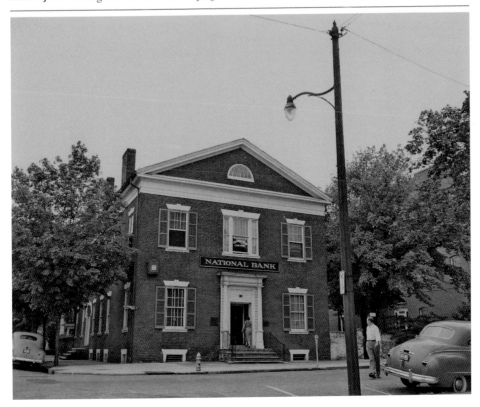

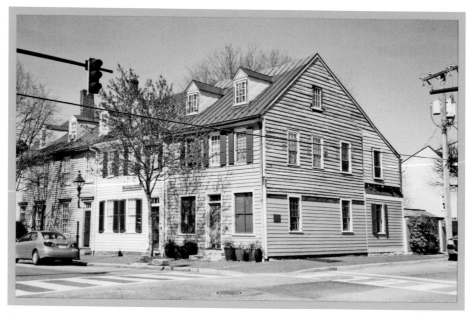

This is known as the John Paul Jones House. It is said to have belonged to his brother William, but the house was built after William's death. The home, which lies at the corner of Caroline Street and Lafayette Boulevard, has seen many uses, frequently as a corner grocery. Its name persists. Now it has returned to its roots and become a private residence. Its address remains 501 Caroline Street. (Above, TK; below, LOC.)

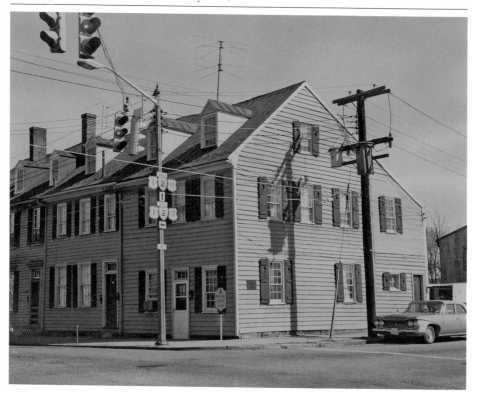

CHAPTER

AROUND TOWN

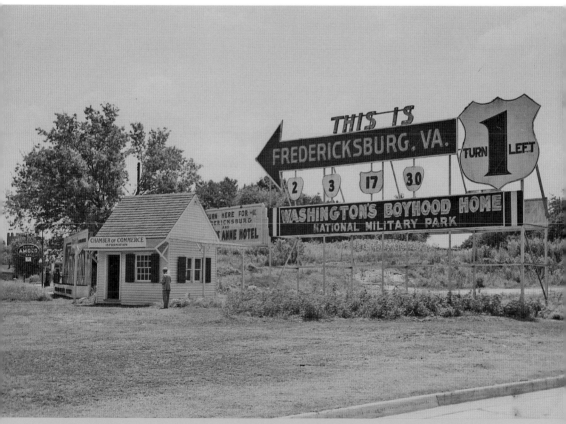

When the Route 1 bypass was completed, motorists were inclined to steer clear of downtown Fredericksburg, so a large, eye-catching sign was erected at the intersection of the highway (now named for Jefferson Davis) and Princess Anne Street. Here, the chamber of commerce set up a small informational kiosk. Later this was replaced by a historic brick building, the former kitchen behind the Farmers' Bank, moved from downtown. For many years, this was the Fredericksburg Visitors Center. Now it's used by an insurance company. (CRHC.)

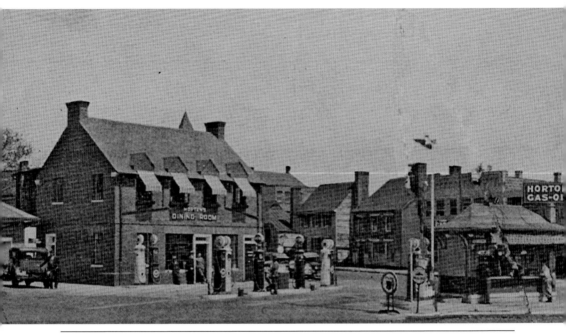

It was a prime spot for motorists to get a bite to eat and top up the gas tank. Here was Horton's at 301 Princess Anne Street, at the junction with Lafayette Boulevard and directly across the intersection from the RF&P train station. This was the southern end of the tourist route through Fredericksburg. Horton's Filling Station and Dining Room advertised the "best of food at the right price." No longer a quick stop for motorists, the building remains remarkably unchanged. Over time, the building has had many uses. Now it houses a hair salon. (Above, CRHC; below, TK.)

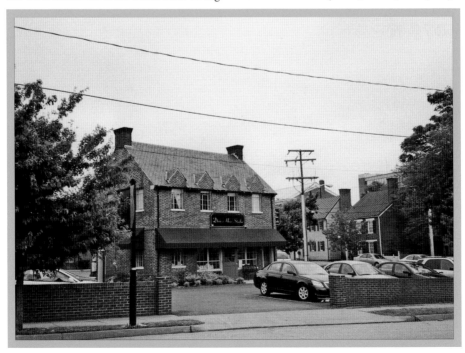

AROUND TOWN

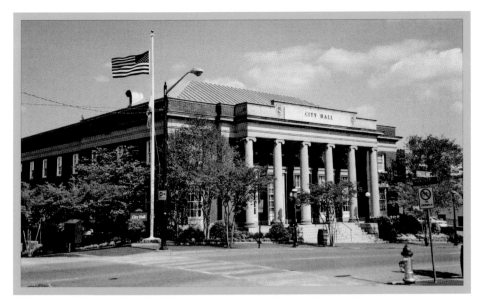

This building at 712 Princess Anne Street has had only two occupants since it was constructed in 1911. One was the U.S. post office, for which it was constructed, and the other is the Fredericksburg City Hall. The change took place in 1979, when the post office moved into its present, larger facility just down the street. At one time, the post office operated a substation at 301 William Street, now occupied by Hyperion Espresso. (Above, TK; below, CRHC.)

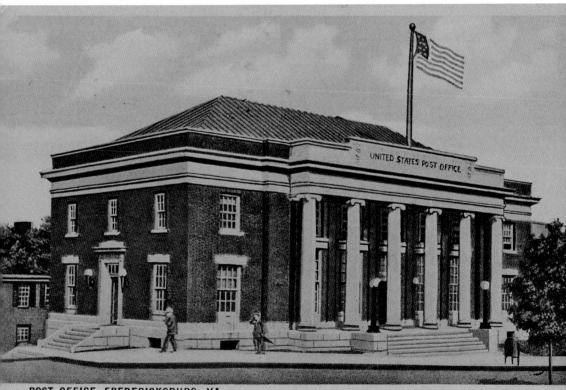

POST OFFICE, FREDERICKSBURG, VA.

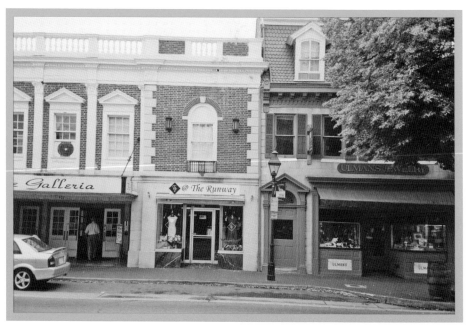

J. Willard Adams opened his bookstore in 1885 at 905 Caroline Street. He also stocked stationery, office supplies, and later, musical instruments, bicycles, and paints. The Singer Sewing Machine Company became his neighbor, a location where Ulman's Jewelry would be established in 1928. Benjamin Pitts's Colonial Theatre joined the same block a year later. Today 905 Caroline Street is home to The Runway, a ladies fashion boutique. (Above, TK; below, VAL.)

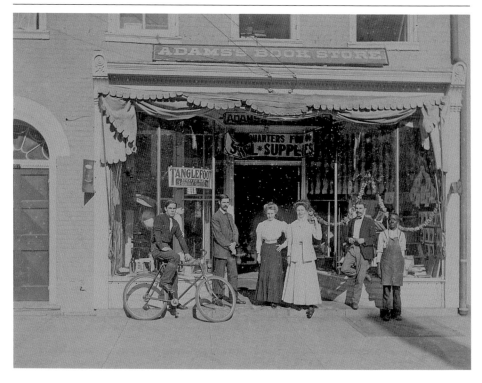

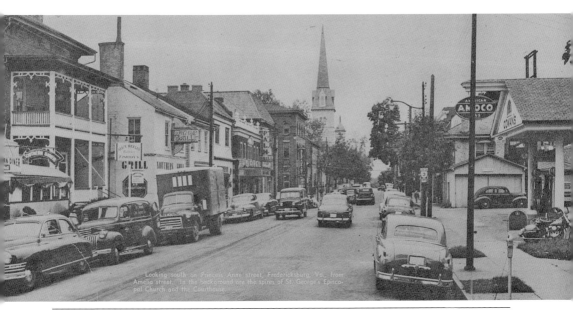

Looking south on Princess Anne street, Fredericksburg, Va., from Amelia street. In the background are the spires of St. George's Episcopal Church and the Courthouse.

Sixty years have wrought many changes to Princess Anne Street, seen here from Amelia Street. This *Washington Star* photograph of January 15, 1950, illustrates two-way traffic, parking meters, and a gas station in this city block, all of which have gone. On the left, one can see the Southern Grill and Diner and also the Palms Restaurant. Across the intersection is the Bradford building, destroyed by fire in 1963. In the background are St. George's Episcopal Church and the courthouse. (Above, CRHC; below, TK.)

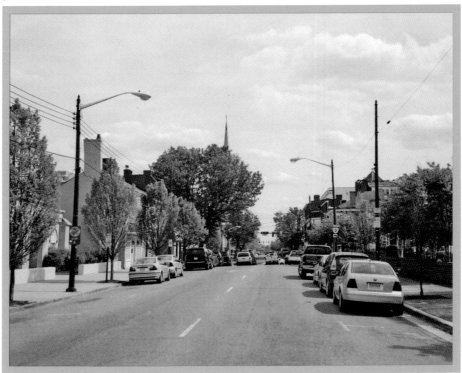

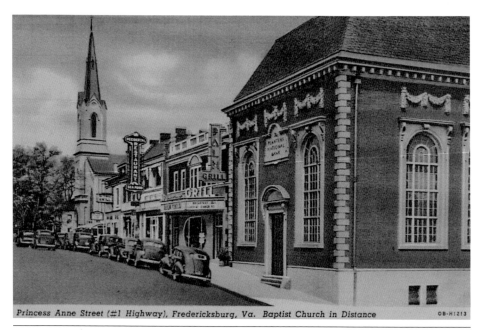

Princess Anne Street (#1 Highway), Fredericksburg, Va. Baptist Church in Distance

OB-H1213

This was and still is a busy intersection in downtown Fredericksburg. The postcard illustrates the main thoroughfare through town when this was U.S. Highway 1. Because the city lies at the midpoint between Washington, D.C., and Richmond, this was a popular stopping point. Princess Anne Street possessed many restaurants, cafés, diners, and gas stations. Next to Planters Bank (now the museum) on the corner was a veritable restaurant row, which included the Palms next door, the Southern Grill and Diner, the Continental Tea Shop, and Colonial Inn. No gas stations survive, and only one restaurant is here now. (Above, CRHC; below, TK.)

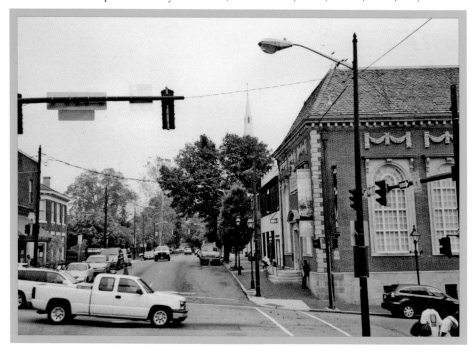

AROUND TOWN

Looking west on Amelia Street from the intersection at Princess Anne Street, the Doggett House is prominent. Smithsonia is next door. The Stevenson-Doggett House, as it is properly called, dates from 1817, having been built by Carter Littlepage Stevenson, an attorney. He added an office, meat house, and kitchen. Among those who lived here were John B. Hall, the city's nuisance inspector, and Dr. Andrew Doggett. Both the Stevenson-Doggett House and Smithsonia interiors have been remodeled extensively. (Above, TK; below, VAL.)

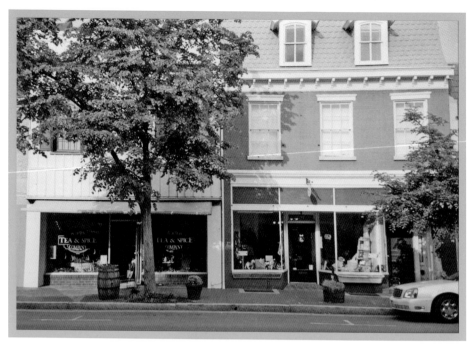

This home at 1011 Caroline Street once belonged to John Happel, a tailor who emigrated from Germany, and later to his son Ralph, who was better known as the chief historian of the Fredericksburg and Spotsylvania National Military Park. The neighbor next door was Brannan's, described as the "pure food" grocer. No. 1013 is still a specialty store offering a wide variety of teas, spices, and other good things. The former Happel home also offers special items for dog owners and their pooches. (Above, TK; at right, CRHC.)

Parts of the old Ficklin flour mill may have been moved onto the property at 207 Amelia Street as early as 1878, but records reveal no dwelling on the site until 1900. Of special interest are stories from Prohibition days of a speakeasy run by a bootlegger here. Although disputed by some, a former city councilman once said he had known of the operation when he was a lad. The small frame building was once divided into a duplex. It is now a single-family home named Camellia Cottage. (Above, HFFI; below, TK.)

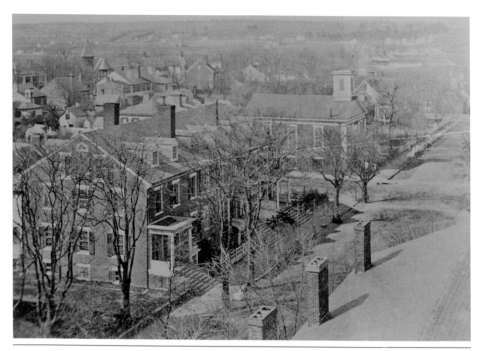

Immigrant Scots and their Presbyterian ministers have been prominent in the community for many generations. They built churches and schools, student dormitories, an asylum for female orphans, and later a row of homey town houses adjacent to the church. This 1881 photograph along George Street shows the former Methodist Church South at the far right; the church was later razed. The now image shows the bank that occupies the site. It also shows the veterans memorial at the far right. (Above, LOC; below, CRHC.)

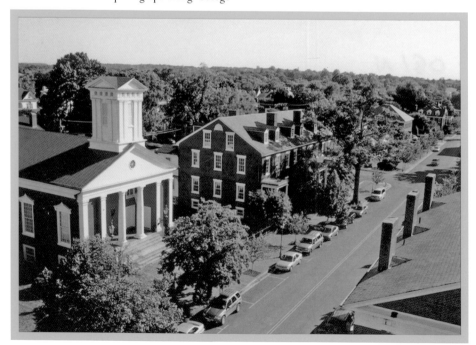